IMAGES
of America

FINGER LAKES
WINE COUNTRY

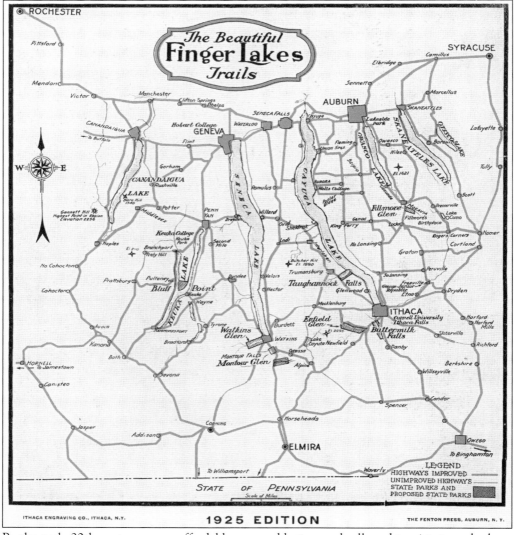

By the early 20th century, more affordable cars and better roads allowed tourists to embark on leisurely driving tours of the Finger Lakes. This detailed road map of the major Finger Lakes is included in the 1925 edition of *The Beautiful Finger Lakes Call You*, by Ross W. Kellogg and the Finger Lakes Association of Central New York. The map shows roadways, as well as current and proposed state parks, such as the one on Keuka Lake's Bluff Point. Today, Keuka Lake State Park is located closer to Branchport. (William Hecht.)

ON THE COVER: Founded in 1865, Urbana Wine Company held New York State Bonded Winery License No. 2. Here, Urbana workers are busy bottling the winery's popular Gold Seal special and extra-dry champagnes in the 1880s. (Glen H. Curtiss Museum.)

IMAGES
of America

FINGER LAKES
WINE COUNTRY

Sarah S. Thompson

ARCADIA
PUBLISHING

Published by Arcadia Publishing
Charleston, South Carolina

Printed in the United States of America

Library of Congress Control Number: 2014952499

For all general information, please contact Arcadia Publishing:
Telephone 843-853-2070
Fax 843-853-0044
E-mail sales@arcadiapublishing.com
For customer service and orders:
Toll-Free 1-888-313-2665

Visit us on the Internet at www.arcadiapublishing.com

To Christian, who dared me

CONTENTS

ACKNOWLEDGMENTS

In 2005, my husband and I left the suburbs of Washington, DC, seeking a slower pace and different careers: me, cooking in professional kitchens; him, working in a winery. Ten years, two children, and a few detours later, we are finally embarking on our Finger Lakes winemaking dream. Soon, we will plant a small vineyard on the west side of Seneca Lake.

To collect the images in this book, I relied solely on the generosity of the region's winery owners and their staff, the passionate staff of our local historical societies and museums, and archivists in public and university libraries.

The following list of contributors, along with their cited abbreviations, is a testament to the esteem in which the Finger Lakes community holds the region's winemaking past and its future: Fred Frank and Erin Flynn, Dr. Konstantin Frank Vinifera Wine Cellars (DKF); John McGregor, McGregor Vineyard and Winery (MVW); the Peterson family and Lindsay Case, Swedish Hill Winery (SHW); Cathy Zimdahl, King Ferry/Treleaven Winery (KFW); Hermann Wiemer and Oskar Bynke, Hermann J. Wiemer Vineyard (HJWV); Laura Wagner-Lee and John Wagner, Wagner Vineyards (WV); Lillian Taylor, Sean King, and the Greyton H. Taylor Wine Museum, Bully Hill Vineyards (BHV); Brad Phillips, Hazlitt 1852 Vineyards (HV); Jon Luckenbach, Hazlitt's Red Cat Cellars (RCC); Jim and Carol Doolittle, Frontenac Point Vineyard & Estate Winery (FPV); Trafford Doherty, director, and Rick Leisenring, curator, Glen H. Curtiss Museum (GHCM); Gary Cox, chairman, Narrative and Images Committee and the Winery Group, Finger Lakes Museum (FLM); John H. Potter, director, and Charles Mitchell, curator, Yates County History Center (YCHC); Michael Fordon, library coordinator, Frank A. Lee Library, New York State Agricultural Experiment Station, Cornell University (FALL); Karen Osburn, archivist, Geneva Historical Society (GHS); Greta Selin-Love, archives assistant, Naples Public Library and Archives (NPL); Terri Grady, Dundee Area Historical Society (DAHS); Jim and Rosemary Covert, Lodi Historical Society (LHS); William Hecht, photographer/archivist (WH); the Fred & Harriett Taylor Memorial Library (FHTML); the Eastern Wine and Grape Archive, Cornell University (EWGA); HathiTrust (HT); and MagazineArt.org (MA).

The following people and resources also provided me with invaluable information: John Brahm, Tina Hazlitt, Sayre Fulkerson, Steve DiFrancesco, Grace Younglove Hudson, Tom Trynski's Fultonhistory.com, Richard Sherer's *Crooked Lake and the Grape*, the *Crooked Lake Review*, and the USGenWeb Project.

Introduction

The story of New York's Finger Lakes wine country began nearly two million years ago during the Ice Age, when continental glaciers in Canada began moving south. As they flowed, the thick ice sheets gouged out valleys between several northward flowing rivers. The glaciers finally receded from central New York about 11,000 years ago, leaving behind huge soil and rock deposits that dammed these valleys, which then flooded to form 11 lakes.

The Finger Lakes region encompasses these 11 long, narrow lakes, aligned north to south like fingers on a pair of hands. There are six major lakes: Canandaigua, Keuka, Seneca, Cayuga, Owasco, and Skaneateles. The smaller ones are Honeoye, Canadice, Hemlock, Conesus, and Otisco. Finger Lakes wine country centers on the four largest lakes: Canandaigua, Keuka, Seneca, and Cayuga. All have Native American names, given to them by the people of the Seneca, Cayuga, and Onondaga nations who settled there long before European contact.

Canandaigua Lake lies farthest west and is the fourth-largest at 15.5 miles long and a maximum depth of 276 feet. Its Seneca name translates to "the chosen place," and the city of Canandaigua sits at the lake's northern end. The town of Naples lies in a valley surrounded by steep hills at the lake's southern end. East of Canandaigua is Keuka Lake, the third-largest. Keuka translates to "canoe landing" in the Seneca language, though early European settlers dubbed it "Crooked Lake" because of its unique Y-shape. The hamlet of Branchport is located on Keuka's northwestern arm, the village of Penn Yan on its northeastern arm, and the village of Hammondsport at its headwaters.

At Penn Yan, Keuka Lake flows eastward along an eight-mile outlet creek that drops 270 feet to empty into Seneca Lake, the deepest lake. Seneca means "place of the stone," which may refer to the lake's steep shores or the many gorges and glens carved from those heights. Seneca Lake's maximum depth is 650 feet at the US Navy's sonar test facility moored offshore near the village of Dresden. The city of Geneva rests at Seneca's northern end, with the village of Watkins Glen at its headwaters. Farther east, Cayuga Lake is the longest and largest lake of the four, at 38 miles long and 3.5 miles wide at its widest point. Its Iroquois name translates to "boat landing." The city of Ithaca, home to Cornell University and Ithaca College, is located at Cayuga's headwaters. At its northern end, Seneca Lake empties into Cayuga via several streams that wind through the towns of Waterloo and Seneca Falls, then eventually joins the Erie Canal.

The geologic history of the Finger Lakes region—its prehistoric inland sea and glacial lakes— shaped the land into an agricultural utopia. The soils are rich and diverse, derived from deposits of shale, sandstone, and limestone. Feeder streams dropping through steep glens provide irrigation and energy, while the deep lakes moderate the temperature of land closer to shore, keeping it several degrees cooler in summer and warmer in winter. Seneca Lake maintains a constant 39 degrees Fahrenheit beyond a depth of 15 feet. The Iroquois people first took advantage of these microclimates for agriculture, cultivating wild plums, cherries, and peaches into flourishing lakeside orchards.

The first major influx of European settlers to the Finger Lakes came after the Revolutionary War, when New York veterans claimed one 600-acre lot each in the Military Tract of Central New York, an area encompassing 28 townships carved from the conquered Iroquois territory. Another wave of settlers came after the Erie Canal opened in 1825. The canal connected western New York to goods and markets in the Great Lakes region and the Eastern Seaboard. Canandaigua, Keuka, Seneca, and Cayuga Lakes soon became busy thoroughfares for commerce, filled with steamboats and barges.

Some of the first goods transported on those steamers were grapes and wine. Commercial cultivation of grapes in the Finger Lakes began on Keuka Lake in 1836; winemaking followed in 1860, though at least one farmer in New York's Genesee River Valley (just west of the Finger Lakes) began selling wine commercially as early as 1832. From these beginnings, Finger Lakes wine country spread until it extended from the southwest side of Canandaigua Lake to the east side of Cayuga.

Today, the Finger Lakes region has nearly 10,000 acres of grapes in production, with 119 wineries and counting. But the path to prosperity has not been smooth. Prohibition left its indelible mark on the industry. Less than 40 years ago, only 10 bonded wineries remained in the entire Finger Lakes region; before 1920, there were 17 wineries in Hammondsport alone. Yet Prohibition was just the proverbial straw that broke the camel's back. The early 20th century was a hotbed of rapid changes and progress in viticulture practices, agronomy, transportation, and technology. Many of these changes displaced the region's grape growers and winemakers from once profitable markets.

Part of the problem was that the Finger Lakes wine industry was historically based on growing table grapes and making wine from native American grape varieties. Though German and French settlers brought Old World wine culture with them to the Finger Lakes, they had to adapt to using grapes that would grow. Sometimes those grapes were the native varieties growing wild on trees and fence posts—primarily either of the species *Vitis labrusca* or *Vitis riparia*. More often, farmers cultivated hybrid grape varieties developed by either accidental or intentional crossbreeding of grape species. Most of the varieties grown and used for winemaking in the Finger Lakes in the early 20th century were either native grapes or hybrids of native and vinifera—the European grape species prized for winemaking. The first major wine grape in the Northeast was Catawba, a native hybrid most likely crossed with vinifera. The earliest European settlers in the American colonies had brought cuttings of vinifera grape vines with them; accidental crossings often happened in gardeners' backyards. But after centuries of failure, most horticulturists had concluded that pure vinifera grapes could not be grown profitably east of the Rocky Mountains.

Finger Lakes wineries barely weathered Prohibition. When they came back, they relied almost exclusively on native and hybrid grapes, which also were used for juice and jelly. Yet consumers' tastes were changing. Sweet fortified wines were still popular, but so were high-octane cocktails. An entire generation had now never been exposed to the unique "foxy" characteristics of New York's native wines. At the same time, California growers were increasingly making bulk vinifera grape juice available to New York winemakers as a means to augment the taste and color of their wines.

It is fitting then that the Finger Lakes, once the heart of the early US wine industry, would become the proving ground for pioneering winemakers and growers interested in challenging vinifera's commercial viability for the northeastern wine industry. This spirit extended beyond vinifera to encompass intentional development of new hybrid grape varieties that carry specific traits for which northeastern winemakers are looking. The result? Today, Finger Lakes vineyards boast the most diverse plantings of native, hybrid, and vinifera grape varieties of any area in eastern North America. Over 30 varieties are made into wine here, with native varieties accounting for 60 percent of production, hybrids for about 25 percent, and vinifera for roughly 15 percent.

In the past 40 years, the Finger Lakes region has experienced a 1,000 percent increase in the number of its wineries. This rapid growth is largely due to passing of the New York State Farm Winery Act. The act, passed in June 1976, removed regulatory and financial hurdles for grape growers to make wine from their crops and sell it directly from their farms to consumers.

With it, growers could now make a living after the region's remaining large wineries canceled their contracts in the early 1980s. In 1982, the Finger Lakes region was designated as an official American Viticultural Area (AVA). Seneca and Cayuga Lakes have their own designated AVAs, each entirely contained within the Finger Lakes AVA. The designation refers to the unique geographic characteristics of these areas and to the fact that 85 percent of the grapes used to make wine are grown there.

Though central New York can have bitterly cold winters and late frosts, the broad Finger Lakes region has roughly 2,500 growing degree days (GDDs), though this varies by site. GDDs are a common tool used by farmers and scientists to predict plant growth and development; the GDD index is calculated using the daily maximum and minimum air temperatures, combined with the highest and lowest temperatures each plant can handle before growth shuts down. The region's GDDs are on par with, or above, those of France's Burgundy and Bordeaux regions and Germany's Franken wine region. This is one reason that the Finger Lakes' leading wines are made from cool-climate, aromatic white vinifera varieties like Riesling and Gewürztraminer, as well as sparkling wines and those made from the French American hybrids Traminette, Vignoles, and Seyval Blanc. Red wines of the Finger Lakes tend to be lighter bodied with earthy accents. Again, cool-climate varieties like Pinot Noir, Cabernet Franc, and Lemberger (also known as Blaufrankisch) are predominant. Several Finger Lakes wineries are now garnering national and international praise; Rieslings and sparkling wines receive particular recognition. *Wine Spectator* magazine devoted its January-February 2013 issue to the first complete tasting and analysis of Finger Lakes wines and, since 2010, has selected several Finger Lakes Rieslings for the magazine's Top 100 Wines list.

Like wine itself, the history of Finger Lakes wine country is based on the grape. Wine is an agricultural product and intimately tied to stories of the region's growers, vineyardists, pickers, packers, amateur horticulturists, and scientists. This book is not meant to be exhaustive, nor is it meant to cover each of the hundreds of wineries that have opened in the region since the 1976 Farm Winery Act. Instead, it is intended as a selective presentation of archival images representing key moments in the 150-year history of Finger Lakes wine country. The hope is that readers walk away with a better understanding of the Finger Lakes' deep winemaking roots and its part in America's wine history, leading to an even greater appreciation of the region's bright future.

One

WINEMAKING TAKES ROOT

Keuka Lake is the birthplace of Finger Lakes grape culture. In the mid-1830s, farmers to the west in Livingston County (in the Genesee River Valley) began experimenting with grape growing and winemaking, which was having success at that time in Ohio's river valleys. Keuka Lake farmers took note and began setting out vineyards on their hillsides to take advantage of the lake's protective influence. The first shipment of fresh grapes from this area was made via the Erie Canal in 1845. From there, plantings rapidly increased and the lake's steamers were the main transportation to city markets. Like their Ohio and Livingston County peers, the first Keuka Lake vineyardists were foremost winegrowers, planning from the beginning to turn at least some of their crop into wine and brandy. By 1859, U.P. Hedrick (botanist, horticulturist, and author of the seminal *Grapes of New York*) estimated that 400 to 500 acres of vineyard surrounded Keuka Lake.

It takes roughly three years for new vines to come into bearing. By 1860, the vineyards on Keuka Lake were mature, and local growers and businessmen began incorporating to turn their grapes into profitable wine companies. At the turn of the 20th century, there were nearly 20 wineries operating in the Hammondsport area. Many of these specialized in producing fortified and sparkling wines made from native grapes. Sparkling wines were made in the labor-intensive and expensive traditional method, or *méthode champenoise*.

Winemaking soon spread to Canandaigua and Seneca Lakes. The table grape market continued to expand alongside the wine industry, especially once railroads came to the grape-growing districts. By the 1890 season, local winemakers were purchasing roughly a quarter of the Lake Keuka district's 20,000-ton grape harvest. On Cayuga Lake, only a few small purveyors of wine and brandy existed at this time.

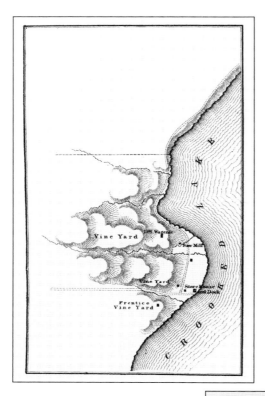

The first commercial vineyards in the Finger Lakes belonged to J.W. Prentiss on the west side of Keuka Lake. In 1836, Prentiss took cuttings from Rev. William Bostwick of Hammondsport, who in 1829 had planted Catawba, Isabella, and Sweet Water vines in his backyard. This map, from Goldsmith Denniston's *Grape Culture of Steuben County*, shows the site of Prentiss's vineyards at Pulteney around 1865. (HT.)

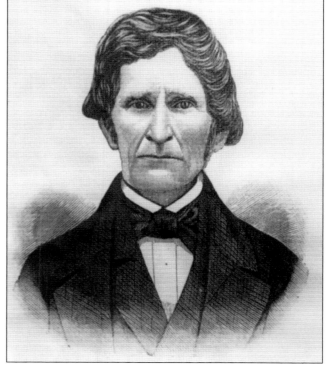

In Livingston County, Samuel Warren (depicted in an engraving from James H. Smith's 1881 *History of Livingston County*) planted vines about the same time as Reverend Bostwick, intending to make wine for personal and sacramental use. Warren's first vintage was 1832, and by 1836, he was advertising his wines to churches in western New York—24 years before the incorporation of New York's first bonded commercial winery. (FLM.)

Early grape growing and winemaking also flourished in Dansville, Livingston County. Here, Frederick "Fritz" Michael tends his 15 acres of vineyard around 1900. Michael came from Hammondsport to start a vineyard and make sacramental wine with two other Germans—Jacob Smith and Andrew Friedel. In 1902, Michael made about 2,000 gallons of wine. (FLM.)

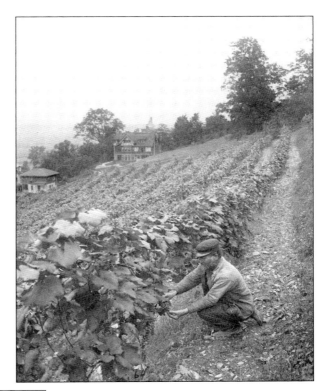

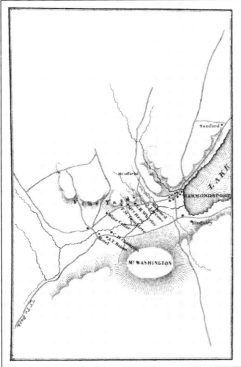

According to Aldrich's 1892 *History of Yates County N.Y.*, Prentiss's success spurred German vineyardist Andrew Reisinger to plant a small vineyard nearby in 1853 "especially for wine and brandy." Reisinger's vineyard was pristine and his methods encouraged Jacob Larrowe, Orlando Shepherd, Grattan H. Wheeler, Charles D. Champlin, and Timothy Younglove to plant vineyards in Pleasant Valley, southwest of Hammondsport (seen here, from Goldsmith Denniston's *Grape Culture of Steuben County*). (HT.)

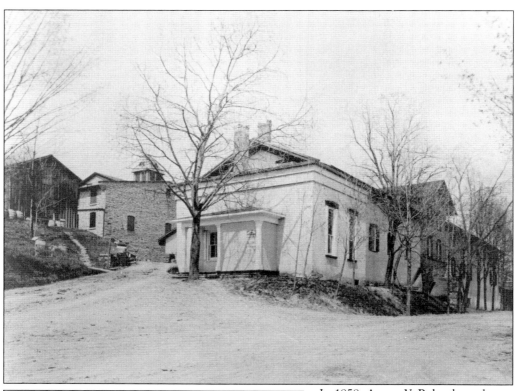

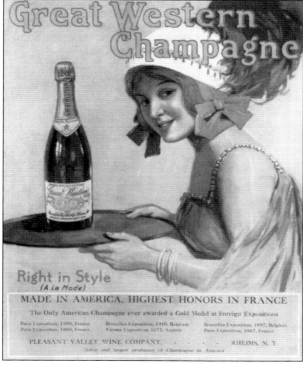

Great Western Champagne
(A La Mode)
Right in Style
MADE IN AMERICA, HIGHEST HONORS IN FRANCE
The Only American Champagne ever awarded a Gold Medal at Foreign Expositions

| Paris Exposition, 1900, France | Bruxelles Exposition, 1910, Belgium | Bruxelles Exposition, 1897, Belgium |
| Paris Exposition, 1889, France | Vienna Exposition, 1873, Austria | Paris Exposition, 1867, France |

PLEASANT VALLEY WINE COMPANY, · · · · RHEIMS, N. Y.
Oldest and largest producers of Champagne in America

In 1858, Aaron Y. Baker brought back 30,000 cuttings from Ohio to Pleasant Valley; by 1860, he had 200 acres of Catawba and Isabella vines. On March 15, 1860, a group of 12 Hammondsport businessmen, including Larrowe, Champlin, Wheeler, and Younglove, consolidated their vineyards to found the Pleasant Valley Wine Company: New York State Bonded Winery No. 1. Above is the winery building around 1900. In 1865, Pleasant Valley produced 20,000 bottles of sparkling Catawba. In 1871, a Boston wine connoisseur dubbed its sparkling wine "the Great Champagne of the Western World." The name stuck. At left, a Great Western advertisement from the May 2, 1914, issue of *Judge* magazine lists its six gold medals won at foreign expositions from 1867 to 1910. (Above, BHV; left, MA, scan and restoration by Mariangela Buch.)

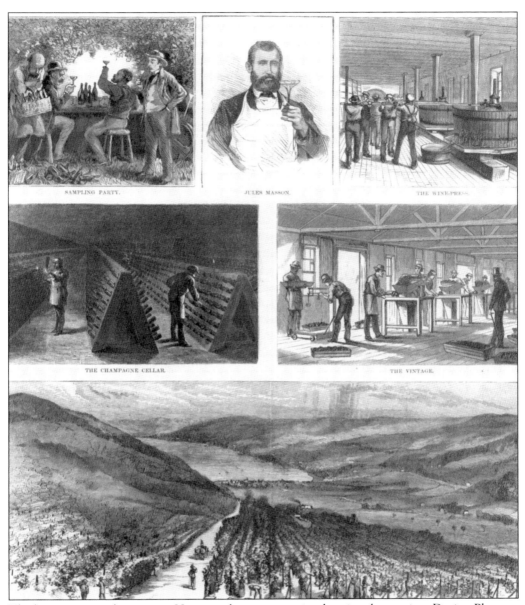

The booming wine business in Hammondsport soon gained national attention. During Pleasant Valley's first year of operation, 18 tons of Isabella and Catawba grapes were harvested, yielding 220 gallons of wine per ton. On August 17, 1862, the first recorded shipment of 100 gallons of wine left the winery. As pictured, *Harper's Weekly* highlighted the winery with a full-page spread in its May 11, 1872, issue. In 1865, Joseph Masson was hired as winemaker at Pleasant Valley. Originally from France, Joseph and his brother Jules had come to Cincinnati, Ohio, to make sparkling wine. There, Jules worked for Nicholas Longworth, a pioneer in making sparkling and still wines from the Catawba grape. Jules left Longworth Wine House in 1869 to succeed his brother as champagne master at Pleasant Valley. (GHCM.)

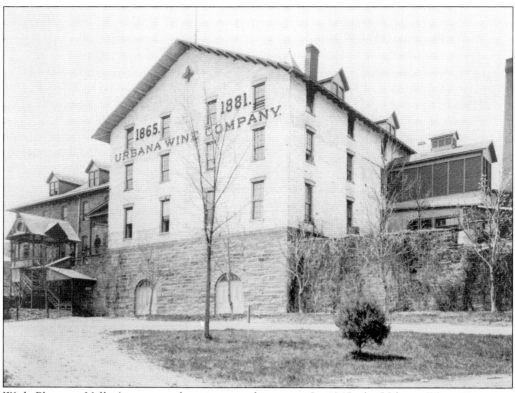

With Pleasant Valley's success, the winery rush was on. In 1865, the Urbana Wine Company was founded north of Hammondsport in the town of Urbana. Eight local businessmen organized the winery, and the company's first winemaker was Frenchman Charles LeBreton. Like Pleasant Valley, Urbana made still and sparkling wines; its sparkling wines were the Gold Seal brand. The c. 1900 photograph above shows the front of the Urbana Wine Company building, with its large stone cellars beneath. In the rare side view of the winery below, Bluff Point can be seen rising above Keuka Lake to the left. (Both, GHCM.)

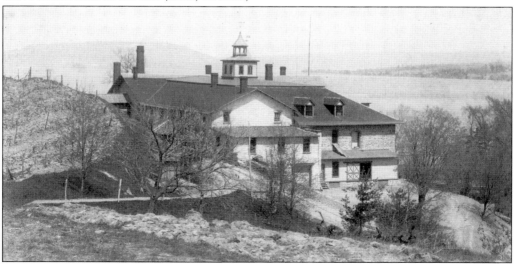

These illustrations of the Urbana Wine Company, from the August 7, 1880, issue of *Scientific American*, show the traditional method for making sparkling wine. From top to bottom, illustrations follow the grapes from vineyard to press room; to primary fermentation, blending of the cuvée (a French term meaning a blend of several still wines), and first corking; to secondary fermentation and riddling; to disgorgement and dosage before final corking. (GHCM.)

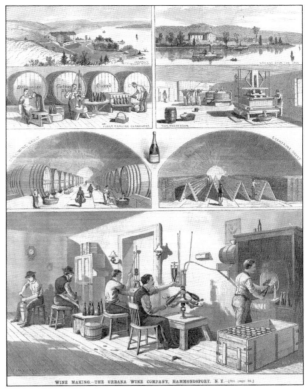

WINE MAKING.—THE URBANA WINE COMPANY, HAMMONDSPORT, N.Y.

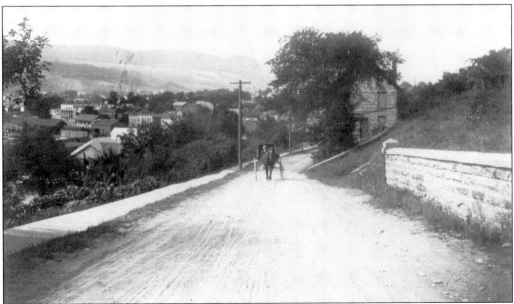

John W. Davis was an original stockholder in the Pleasant Valley and Urbana Wine companies, and in 1884, he held the office of superintendent at Urbana. Here, he is driving up Pulteney Street from Hammondsport toward Urbana's cellars around 1898. Davis also was an officer of the Bath & Hammondsport Railroad Company. (GHCM.)

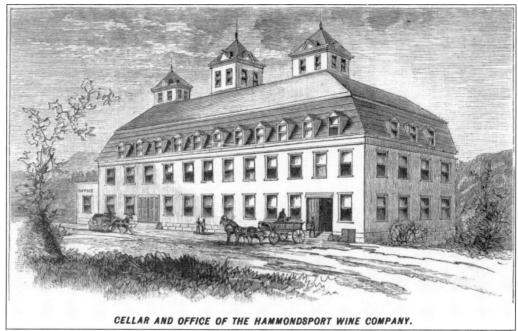

CELLAR AND OFFICE OF THE HAMMONDSPORT WINE COMPANY.

Grattan H. Wheeler and two of his sons founded the Hammondsport Wine Company in 1858, but they did not make wine until about 1867. Above is an illustration of the winery in 1884, from *Keuka: Lakeside Life in Central New York*. This brochure was perhaps the region's first to focus on winery tourism, created "for the promotion of pleasure travel" by the New York City firm of Leve & Alden, travel agent, tour operator, and travel guide publisher. An entire chapter of the brochure is devoted to winemaking and the area's major wineries. Below, workers posing outside the winery building in 1907 are, from left to right, Dan Grimley, Jerome Brownell, unidentified, Piney Bailey, Frank Miller, and Clark Cogswell. (Above, HT; below, GHCM.)

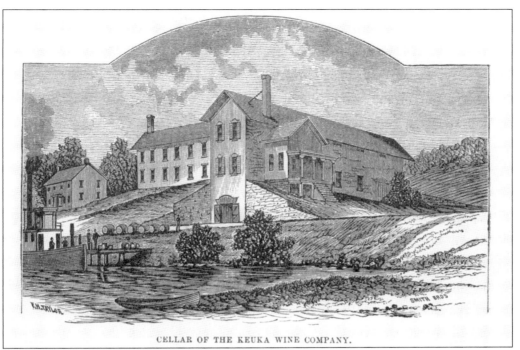

CELLAR OF THE KEUKA WINE COMPANY.

The Lake Keuka Wine Company, located north of Urbana at Gibson's Landing, was originally founded in 1878 as Crooked Lake Wine Cellars. By the time of this engraving, from Henry Kollock's 1882 *State of New York*, the name had changed and the owners were former Urbana Wine Company employees Charles LeBreton and A. Towner. The company advertised its dry Catawba in the 1884 *Keuka: Lakeside Life* brochure as "an excellent tonic and invigorator." In 1898, champagne became the company's sole product; in 1902, the company changed its name to White Top Cellars for its flagship brand. In the postcard below, the building is now identified as White Top Wine Cellar. (Both, WH.)

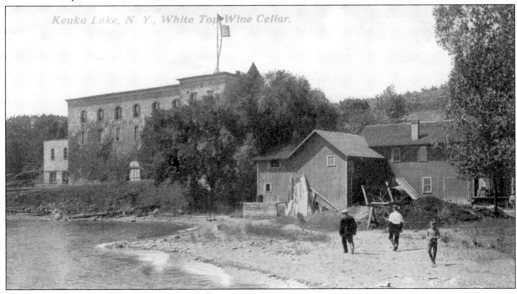

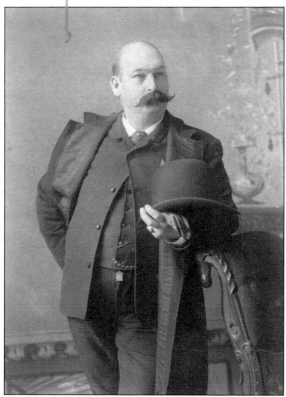

This photograph captures the dapper D. Orville Trimmer of Penn Yan, a salesman for Urbana Wine Company around 1900. Trimmer must have been in demand; he also sold wine for Lake Keuka Wine Company, Hammondsport Wine Company, and White Top Champagne. This is likely an official studio portrait. (GHCM.)

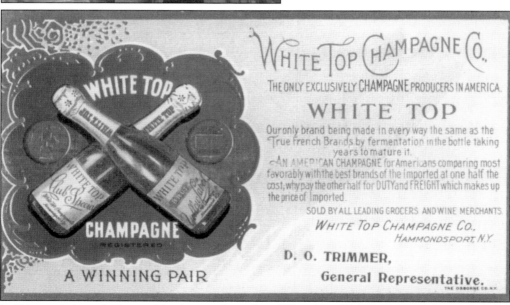

In Trimmer's day, ink blotters like the one above from White Top Champagne Company, produced around 1902, were popular advertising tools. As common then as business cards are today, they were frequently given away by merchants. When writing with a quill pen, the blotters were used to dry excess ink. (GHCM.)

In 1879, Jacob Frey founded the Germania Wine Company just north of the Pleasant Valley Wine Company. Frey had been a baker, hotelier, and tavern owner in Hammondsport. He started by digging a cellar under his hotel and selling wine made elsewhere. By 1884, Germania was producing an estimated 100,000 gallons of wine annually. At that time, the company's specialty was its Excelsior brand champagne and a Riesling, which was said to rival those from French and Rhenish vineyards. However, the grape they called Riesling was not the vinifera grape. In 1892, Frey incorporated to raise capital for expansion. John J. Frey, pictured at right and one of Jacob's sons, was an original stockholder. Below is the winery around 1893, after the addition of a four-story, 3,000-square-foot structure that doubled the winery's capacity. (Both, GHCM.)

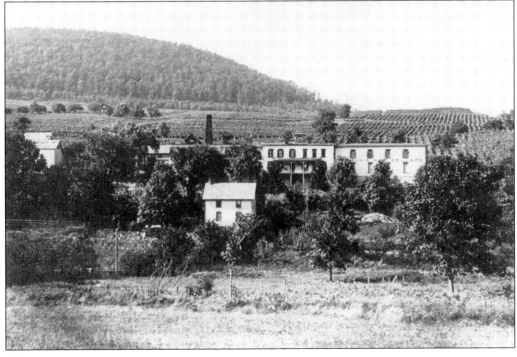

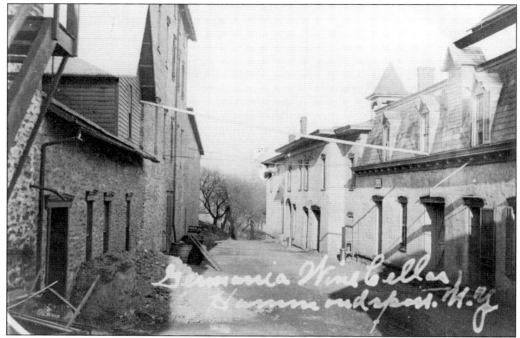

This is a worker's-eye view from behind Germania Wine Company's original building around 1903. The structure on the left is likely the new one built in December 1902, which was three stories high and 77 feet long by 40 feet wide, with two double basements. Small piles of dirt left over from excavation still sit outside the new building. (BHV.)

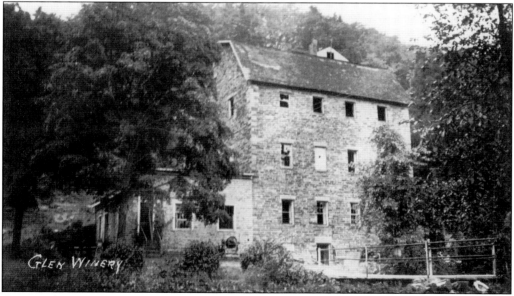

Organized in 1881, the Glen Wine Company moved into the imposing and historic Mallory's Mill, originally built by Meredith Mallory in 1836. The mill operated for just four years, then became a storehouse until its winery reincarnation. In 1901, the company was sold and renamed the Roualet Wine Company for general superintendent and secretary Henri C. Roualet. (GHCM.)

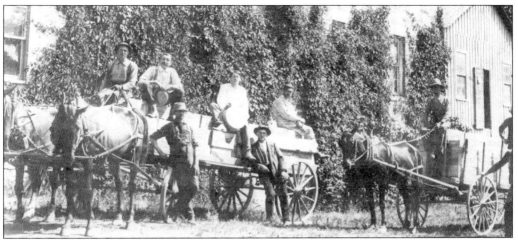

In 1901, workers of the new Roualet Wine Company pose with loaded carts in front of the former Glen Wine Company building. The man seated on the wagon holding his hat is Henri C. Roualet. A 1935 flood ruined the building and the winery's stock; the company never reopened. (GHCM.)

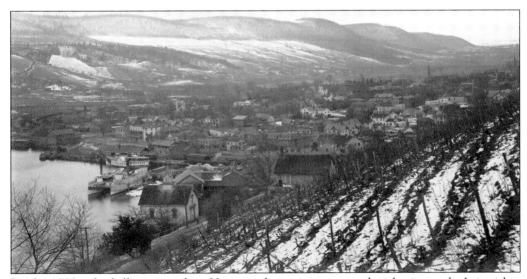

By the 1880s, the hills surrounding Hammondsport were covered with vineyards. It is either early winter or spring in this photograph, as the hillsides are dusted with snow, but the harbor is not frozen. There, the steamship *Holmes* is visible in dock with two others. The *Holmes* was launched in July 1883. (FHTML.)

Walter Taylor, founder of the Taylor Wine Company, was born in 1858. Walter's father, George, was a cooper (or barrel maker) by trade. Walter worked with his father until 1878, when he married Addie Chapman and moved to Hammondsport to start a vineyard on a site overlooking the lake that locals called Bully Hill. In 1880, Walter bought seven more acres up the road, where he built a homestead and started making a popular blend of Concord and Ives grape juice. He soon began experimenting with wine, finally launching the Taylor Wine Company in 1883. It became New York State Bonded Winery No. 17. Below is a c. 1890 view looking down from the hillside vineyards toward Keuka Lake and the original Taylor winery. (Both, BHV.)

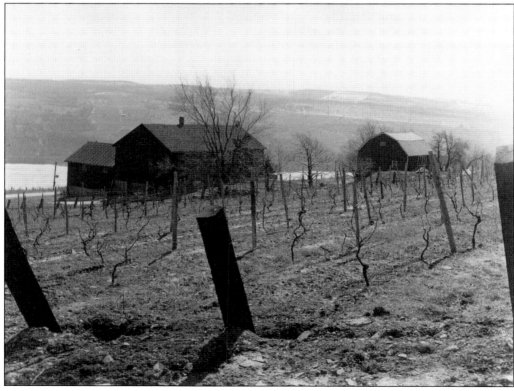

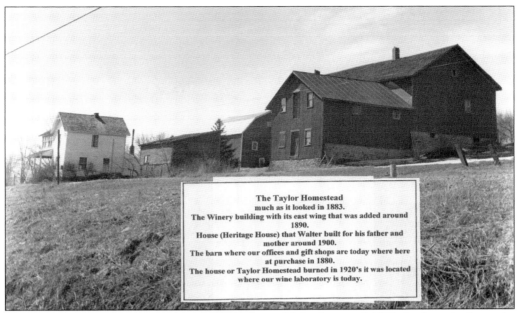

> **The Taylor Homestead**
> much as it looked in 1883.
> The Winery building with its east wing that was added around 1890.
> House (Heritage House) that Walter built for his father and mother around 1900.
> The barn where our offices and gift shops are today where here at purchase in 1880.
> The house or Taylor Homestead burned in 1920's it was located where our wine laboratory is today.

Above is the Taylor homestead on Bully Hill, established around 1883. In front is the main winery building with stone cellars, flanked on the left by the house Walter Taylor built for his parents around 1900. The winery's east wing (extending behind) was built in 1890. The building below first belonged to the Columbia Wine Company, which was founded in 1887 by Joseph Moosburger, who at the time was winemaker for the Hammondsport Wine Company. It operated successfully until 1920, when Walter Taylor bought the business to expand his winery. With the expansion, Taylor began bottling in glass. Before this, he had sold most of his juice and wine in smaller wooden kegs. (Both, BHV.)

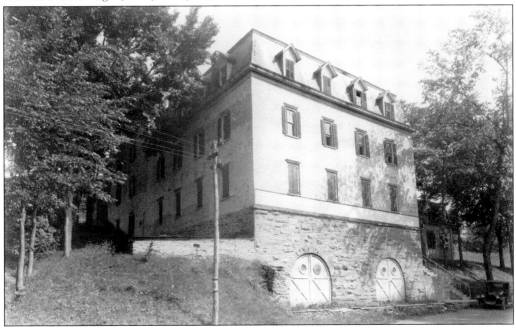

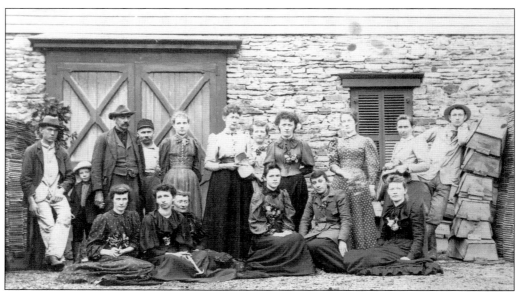

Timothy Meigs Younglove, an original stockholder in Pleasant Valley Wine Company, founded the Monarch Wine Company in 1887 with his son Oliver. In 1894, they had 50 acres of vineyard and manufactured 600,000 grape-shipping baskets. Here, Oliver (standing third from left) holds his son Timothy Knox's hand while posing with winery workers and basket makers around 1893. In June 1906, a fire destroyed Monarch's cellars. (GHCM.)

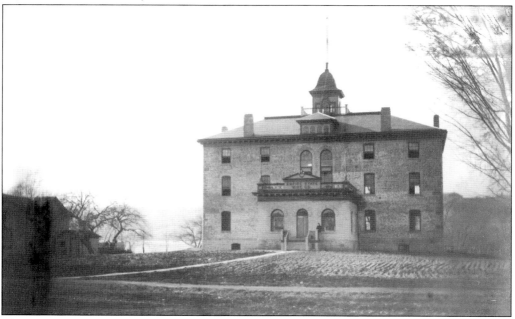

The Empire State Wine Company was incorporated in Penn Yan in 1897. It produced wine under the State Seal Champagne, Vineyard Queen, and Sweet Catawba labels. Seen here around 1896 is the new winery, located near the entrance to the Keuka Lake outlet. During Prohibition, Empire State made sacramental wines, Nikko brand grape juice, and medicinal wine. The winery closed in 1944. (YCHC.)

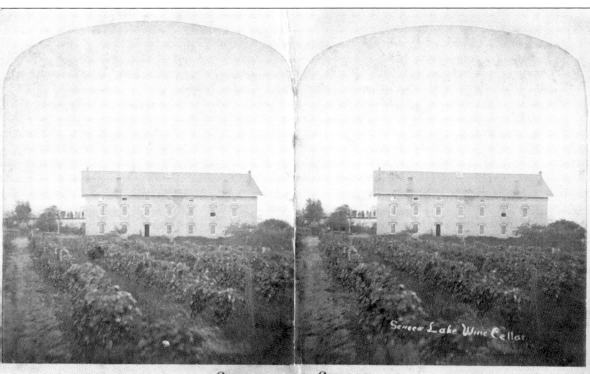

Severne-on-Seneca.

On the west side of Seneca Lake, farmers began planting small vineyards around 1862. One such vineyard, about 16 miles east of Penn Yan near Starkey Station, belonged to Anson Dunlap. Another, just three acres of Catawba and Isabella near Himrod, was planted by James Valentine. In 1866, seven men from the towns of Hammondsport, Bath, Liberty, and Milo formed the Seneca Lake Grape and Wine Company and purchased this area known as Shingle Point, along with 210 acres of adjoining land. In 1867, the company extended its vineyards to 125 acres, which at the time was thought to be the largest in the state. In 1870, the company erected a large stone building and released its first vintage, making 14,000 gallons of wine. This is a rare stereoscopic photograph of Seneca Lake Wine Cellars around 1870. Winery president Judge Jacob La Rue changed the name of their location to Severne-on-Seneca, which is said to be "of Swiss derivation" in Stafford Cleveland's 1873 *History and Directory of Yates County*. (YCHC.)

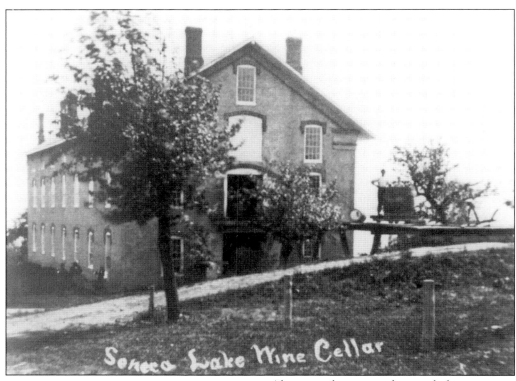

Seneca Lake Wine Cellar

Above, workers pause for a real-photo postcard while transporting a barrel into (or out of) Seneca Lake Wine Cellars, the first winery on Seneca Lake. In 1901, the company merged with the Genesee Valley Wine Company in Rochester to create the Severne Wine Company. At this time, the winery had a 200 acre vineyard; a four-story, 7,200 square foot building with double cellars below; and, as described in a December 1901 consolidation notice in *Western Druggist* journal, "every up-to-date improvement in labor saving machinery." On September 13, 1905, a fire at the winery destroyed over 100,000 gallons of fermenting juice and several thousand bottles of champagne. The notice in the *Wine and Spirit Bulletin* calls it "almost a total loss." A year later, Empire State Wine Company bought what was left of the business. (Above, YCHC; left, HT.)

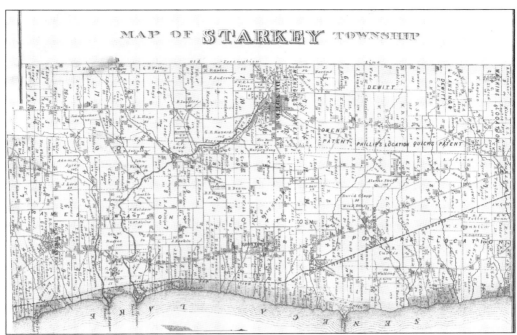

MAP OF STARKEY TOWNSHIP

By 1876, a good portion of the shore on Seneca Lake's west side in the town of Starkey—from Big Stream Point up to Severne-on-Seneca—had been planted to vineyard (see the areas shaded with vertical hatching above). This map of Starkey from the 1876 *New Historical Atlas of Yates County, NY* shows Anson Dunlap's vineyards (Lot No. 35), south of Starkey Station, as well as those of Dr. Byron Spence at Squaw Point (Lot No. 25). Dr. Spence's achievements, and his vineyards, were noteworthy enough to be featured in this illustration (right) from the atlas. Today, the site of Spence's original vineyards is Villa Bellangelo Winery. (Both, YCHC.)

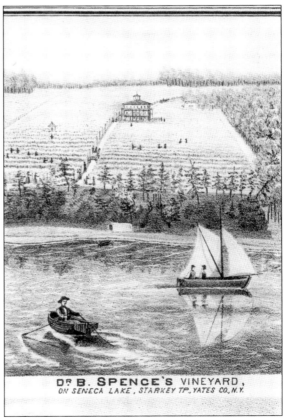

DR. B. SPENCE'S VINEYARD,
ON SENECA LAKE, STARKEY TP., YATES CO., N.Y.

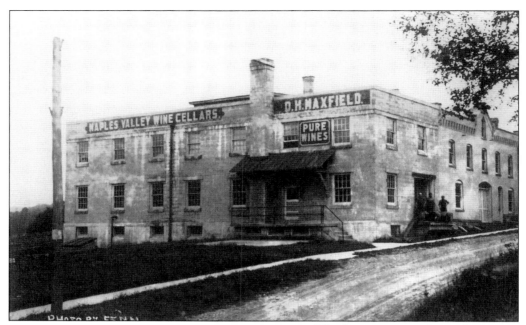

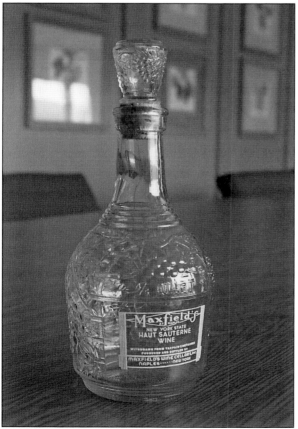

The first winery on Canandaigua Lake was the Maxfield Winery (above) founded by German immigrant Hiram Maxfield in 1861. The company held New York State Bonded Winery License No. 6. This factory-like building was located in Naples, at the head of Canandaigua Lake. Maxfield also was Naples's leading banker. Not wanting the competition, Maxfield supposedly refused to lend money to Swiss immigrant John Jacob Widmer, a fledgling winemaker; Maxfield's plan failed, however. The building may not have been pretty, but Maxfield's bottles were works of art. A modern photograph by John Adamski (left) shows an old bottle of Maxfield's Haut Sauterne wine. (Both, FLM.)

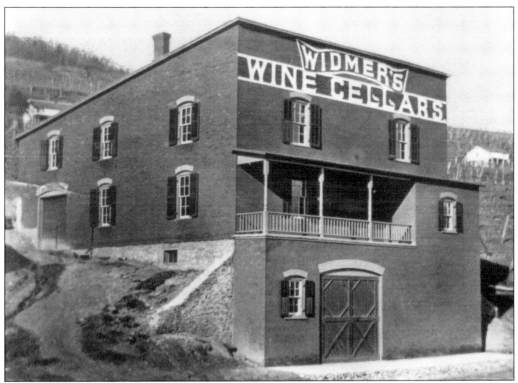

In 1882, John Jacob Widmer finally founded his Widmer's Wine Cellars in Naples; Widmer would go on to buy out Maxfield's wine business in 1941. The photograph above shows the original Widmer brick cellar and winery building. Below is another view of Widmer's Wine Cellars not long after 1894, the year the Middlesex Valley Railroad completed construction of a branch connecting Naples to the Lehigh Valley Railway in Geneva. By this time, the winery included several other buildings and storehouses, all with easy access to railcars for transportation. Note the vineyards completely covering the steep hills rising behind the winery. (Both, FLM.)

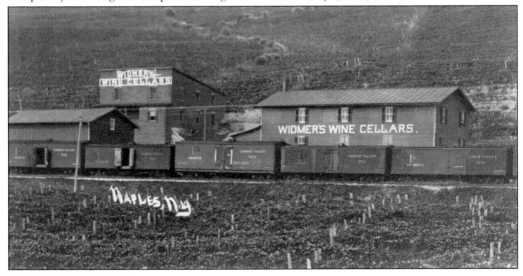

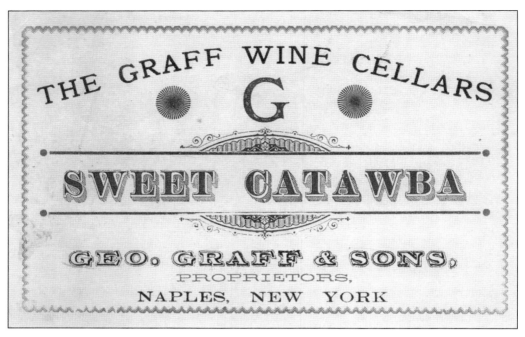

THE GRAFF WINE CELLARS

G

SWEET CATAWBA

GEO. GRAFF & SONS,
PROPRIETORS,
NAPLES, NEW YORK

George Graff founded the Graff Wine Cellars north of Naples around 1886, not long after he and his wife had immigrated to the valley from Germany. In 1911, the Graffs were still making well-regarded wine, like the Sweet Catawba pictured above, when Milliken reported on the town in his *History of Ontario County, NY and Its People*. The photograph below shows the extent of Widmer's vineyards on Canandaigua Lake in the early 1900s. Here, the photographer looks across Widmer's vineyards, covering the steep hills around Naples on the lake's western shore. A few buildings in the town of Naples, resting in the valley below, are barely visible in the distance at left. (Above, FLM; below, RCC.)

Two

TABLE GRAPE MANIA

From Keuka Lake, viticulture spread to Canandaigua, Seneca, and eventually, Cayuga Lake. Since the 1850s, hundreds of acres of Catawba, Isabella, Delaware, and Concord vines had been planted from the southern end of Canandaigua Lake to the west side of Seneca Lake. But it was not until the 1880s that the table grape market took off, the reason for which is twofold. First, the grape supply in the region had finally reached a consistent level to meet demand in the cities. Second, advances in transportation and technology made packing and shipping fresh grapes much easier. In the early days of commercial grape growing, Keuka Lake growers sent one shipment at a time on steamships to Penn Yan for transport to Seneca Lake via the Crooked Lake Canal along the Keuka outlet, then on to Cayuga Lake and the Erie Canal. The journey was arduous, and grapes often arrived at market unfit for sale.

In 1875, local businessmen chartered the Bath & Hammondsport Railroad (B&H), dubbed the "Champagne Route," to create a faster, cheaper way to get their wines and grapes to market. This short line railroad connected Hammondsport to the main line Erie Railroad in the town of Bath. By the 1890s, shipments to multiple markets via special ventilated produce and ice-packed "stated refrigeration" railroad cars had replaced the canal. In 1897, a trolley line brought grapes to Penn Yan for transfers to the Fall Brook Railway and Northern Central line of the Pennsylvania Railroad from points west—towns like Bluff Point, Branchport, and Kinney's Corners.

Grape culture finally took hold on the east side of Seneca Lake and the west side of Cayuga Lake around 1896 with the coming of the Lehigh Valley Railroad (LV) and the Niagara grape. Table grape mania created new industries: basketmaking factories, packinghouses, icehouses, marketing organizations, and cooperatives. The boom lasted until about 1919, when Prohibition opened the market for bulk grapes and direct sales to truckers made fancy labels, pony baskets, and railroad shipping obsolete.

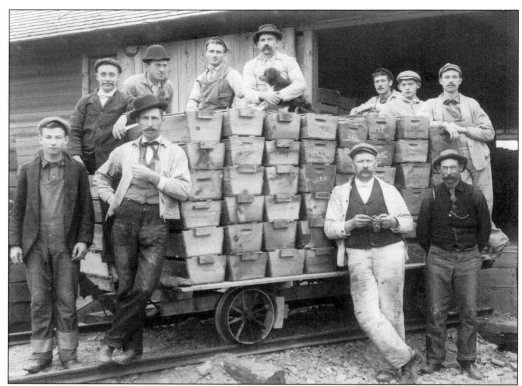

The grape packinghouses of Hammondsport were busy enterprises at the turn of the 20th century. Above, male workers of the S&L (Lyon Brothers) packing company take a break from transporting wooden grape trays around 1915. The slope-sided trays, each holding 30 pounds, were an innovation to help female pickers more easily handle grapes during harvest. Below, the entire Lyon Brothers workforce poses outside the packinghouse around 1900. Women almost exclusively picked and packed the grapes, while men transported full crates from the vineyards to the packinghouses and loaded shipments onto the trains. (Above, GHCM; below, BHV.)

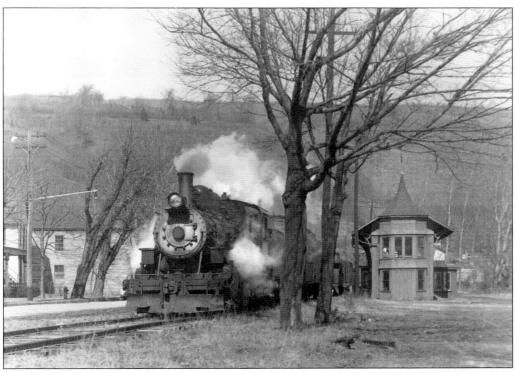

The B&H began service in 1875 to transport table grapes and wine, especially sparkling wine, from Hammondsport to the main line Erie Railroad and the Delaware, Lackawanna & Western Railroad (DL&W) at Bath. Charles Champlin and his associates at the Pleasant Valley Wine Company built the nine-mile short line railroad. Passenger traffic on the B&H peaked between 1889 and 1907; during this time, as many as seven trains ran from Bath to Hammondsport each Sunday. In 1908, the Erie Railroad took control of the B&H and operated it until 1935. Steam Locomotive No. 11, seen above pulling out of the Hammondsport depot, was used during this time. Below, an unidentified man poses with what was likely Caboose No. 1 in the 1930s. (Both, FLM.)

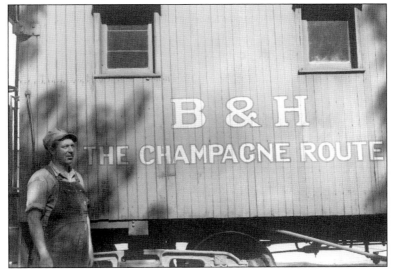

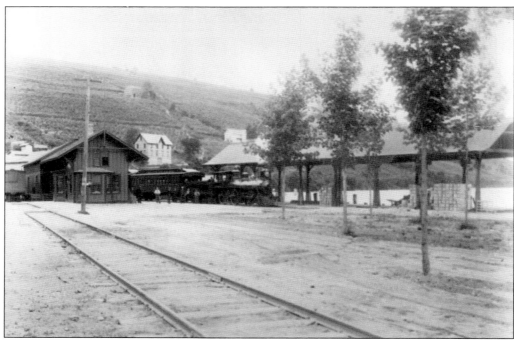

The photograph above captures Hammondsport harbor's busy train and steamship depot around 1900. The B&H passenger train waits at the depot, while what look like empty grape baskets sit on the loading dock at right. The hillsides above the lake are covered with vineyards. The multistory stone building on the hill behind the depot was built in 1883, then acquired by the Lake View Wine Company in 1906. Below, huge crowds at the Hammondsport harbor watch from docks, rooftops, rowboats, and aboard the steamships *Urbana*, *Holmes*, and *Halsey* as the new steamship *Mary Bell* is launched in 1892. (Both, BHV.)

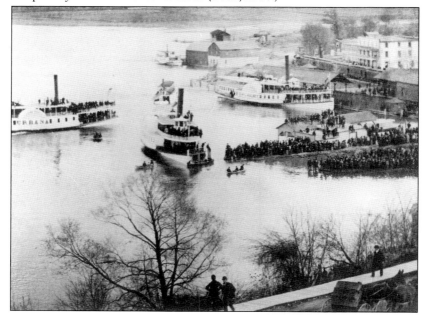

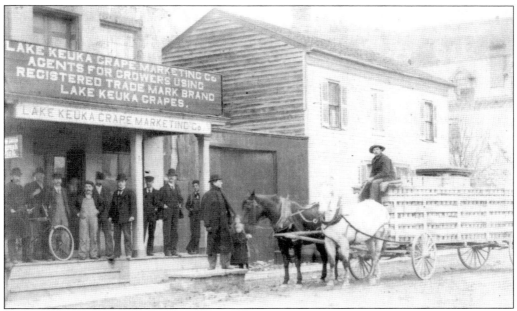

By the 1890s, loading stations at Keuka Lake's north end were shipping roughly 100,000 baskets of table grapes per day, and profits had increased so much that city commission merchants placed agents locally to solicit shipments. Above is one such company, the Lake Keuka Grape Marketing Company in Hammondsport, pictured around 1905. As competition heated up, shippers were forced to build their own brands in order to penetrate new markets. To do this, they gave growers colorful trademarked labels for free, with the understanding that they would be used only for the best quality fruit and not be sold to other shippers. Below, workers pose inside a Keuka Lake grape packinghouse, proudly holding pony baskets bearing the Lake Keuka Grapes label seen on the next page. (Both, YCHC.)

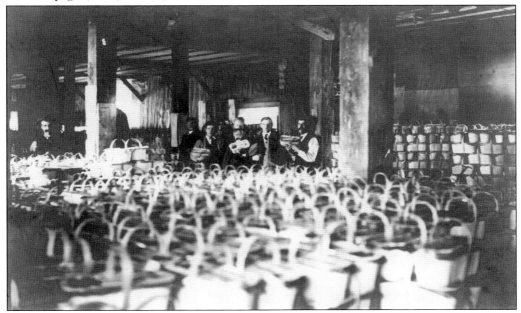

The McMath & Morgan Company sold groceries, ran a large grape packing and shipping house, and manufactured grape baskets in Penn Yan. The firm's owners were Samuel McMath and Charles W. Morgan; John, Samuel's son, succeeded his father in the business until 1932. Their basket factory was located on Water Street, which runs along the Keuka Lake outlet. Above, McMath & Morgan workers pose in front of the factory around 1900. Below is a Lake Keuka Grapes label showing the entire outline of the lake, complete with major towns and steamships plying the waters. In 1917, McMath & Morgan consolidated its business with W.N. Wise and Company. (Above, YCHC; below, GHCM.)

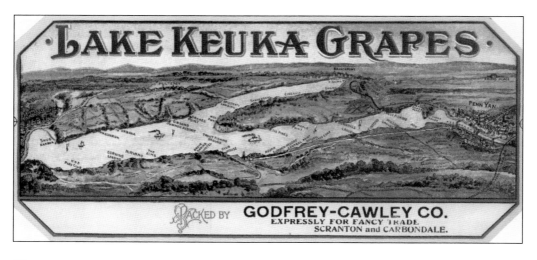

By the early 1900s, McMath & Morgan's business had grown large enough that the telegraph companies provided it with a free private wire and operator in its offices. Here is most likely young John McMath at the firm's office on Delano Place, just east of the outlet on Liberty Street in Penn Yan, around 1919. (YCHC.)

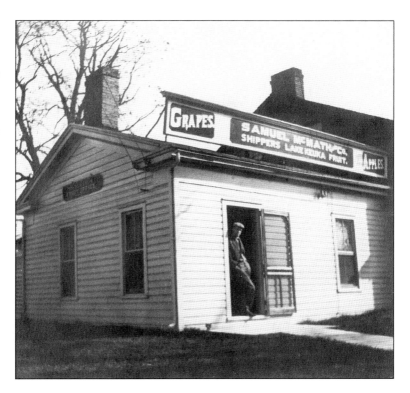

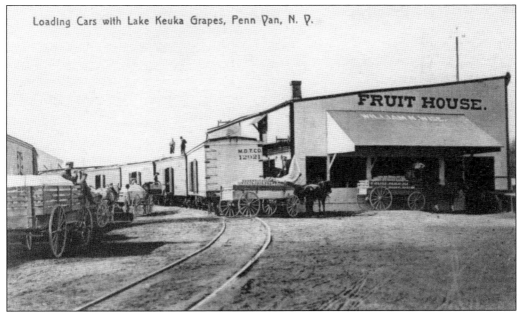

From 1887 to the 1920s, William N. Wise of Penn Yan was called "the Grape King" for his grape packing and shipping success. Getting grapes to market quickly was the key, and Wise could ship 12 railcars at once from his fruit house between Lake Street and the Keuka Lake outlet. (FLM.)

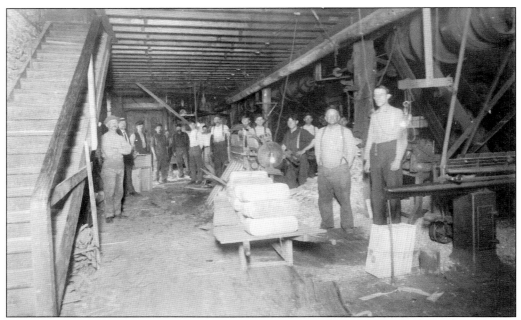

In 1908, Charles E. Guile and Warner Windnagle formed the Penn Yan basketmaking firm of Guile & Windnagle (G&W). The two had worked for their father-in-law George W. Finton's basket business since the late 1880s; when Seneca L. Pratt (Penn Yan's earliest basket maker) retired, he sold his Monell Street factory to Guile and Windnagle. There, the firm made the largest variety of baskets in the country. In its first year, the company sold over three million small grape baskets to local growers. G&W made the popular Climax (or pony) baskets and all kinds of woven baskets. Above, G&W workers manufacture either pine covers or veneers for pony baskets. Below, workers weave various-size baskets from wood veneer. (Both, YCHC.)

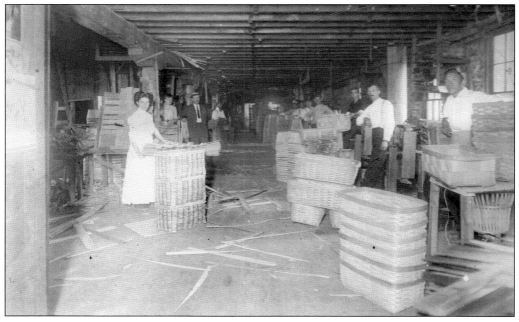

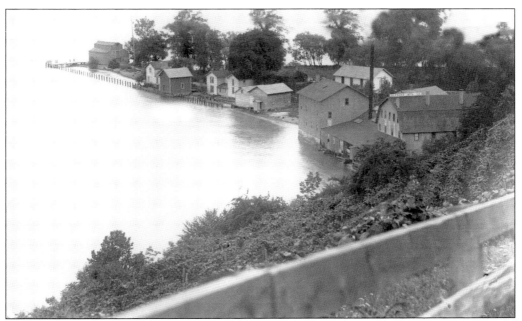

The table grape industry soon expanded to other districts. This is a roadside view of the Glenora Manufacturing Company (the gambrel-roofed building at far right) on Seneca Lake in Dundee. The company was incorporated on February 21, 1893 and, as described in a notice published in the *Watkins Express*, established "to manufacture fruit baskets, swing cattle stanchions, etc." Note the vineyard-covered hillside sloping toward the lake. (DAHS.)

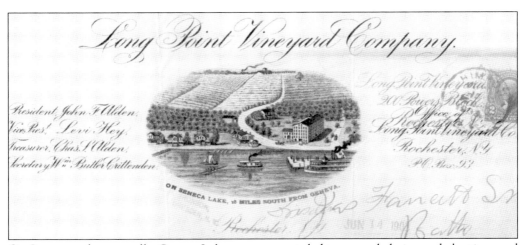

On Seneca and, eventually, Cayuga Lakes, grape mania led to expanded vineyard plantings and the formation of stock corporations. In 1881, four businessmen from Rochester incorporated the Long Point Vineyard Company. This is a rare company letterhead, indicating its location "18 miles south from Geneva" on Seneca Lake at Long Point. (GHCM.)

The coming of the Lehigh Valley Railroad (LV) along Seneca Lake's eastern shore and Cayuga Lake's western shore in 1896 made it easier for farmers to get their fruit to market. The LV had depots at Watkins Glen, Burdett, Hector, Valois, Caywood, Lodi, Gilbert, and Kendaia on Seneca's east side and at Ithaca, Trumansburg, Covert, Interlaken, Sheldrake, Hayt's Corners, Romulus, Waterloo, and Seneca Falls on Cayuga's west side. Above, this early promotional postcard for Wagner Vineyards in Lodi features a drawing of the old Caywood railway depot by artist Bill Benson, based in Ithaca, New York. Below, women pack grapes in a packinghouse likely located near Lodi around 1900. (Both, WV.)

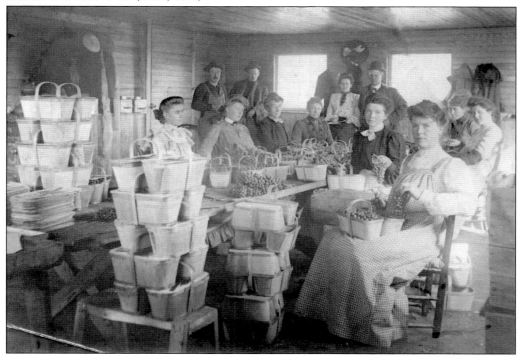

In 1873, nurserymen Claudius L. Hoag and B. Wheaton Clark developed the Niagara grape in Lockport, New York. They formed the Niagara Grape Company, placing free vines with growers in exchange for half the net sales. This is an illustration from the company's 1886–1887 brochure. Hoag and Clark called Niagara, a cross between the Concord and Cassady varieties, "the grape for the millions." (FALL.)

According to Aldrich's 1892 *History of Yates County, N.Y.*, George C. Snow planted the first Niagara grapes in the Finger Lakes in 1881 on Keuka Lake. By 1893 in Seneca County—an area sandwiched between Seneca and Cayuga Lakes—nearly 1,200 acres of Niagara grapes were under management. As the grape business boomed, barrels stayed in high demand. Here, a Penn Yan cooper poses with his young apprentices around 1900. (YCHC.)

THE NEW WHITE GRAPE. NIAGARA.

This new purely native White Grape is a cross between Concord and Cassady. Hardy and as strong a grower as Concord; earlier and better in quality. Bunches large and uniform; very compact. Enormously productive, a four-year-old vine producing 140 clusters, weighing from 8 to 16 ounces each. Possessing qualities as a market grape. Excelling any known variety and confessedly the most valuable for the vineyardist, and is being extensively planted. Selling at 16 to 25 cents per pound, when best California grapes brought 10 to 15 cents. The most desirable white grape ever produced. THE GRAPE FOR THE MILLION. Every vine sold at retail, has the seal of Niagara White Grape Co. attached. This is a fac-simile of a cluster sent for lithographing, weighing 19 oz.

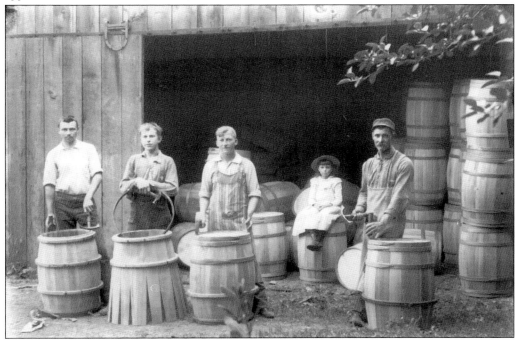

As grape culture grew in the Finger Lakes (and Prohibition loomed), so did the grape juice business. After Dr. Charles Welch's success pasteurizing fresh grape juice in 1869, it became popular for personal and sacramental use; in 1896, Welch's operations briefly were located in Watkins Glen on Seneca Lake. Frank Millen, a Brooklyn wholesaler, brought his grape juice business to Watkins Glen in 1908. Above is his December 1909 advertisement in the *National Druggist.* By 1920, Millen's was bought out by the Bro-Bar Juice Company, which built a massive three-story building covering the entire lot from First Street to the depot at Watkins Glen harbor. Below, men handle barrels at an LV depot on Seneca Lake. (Above, HT; below, LHS.)

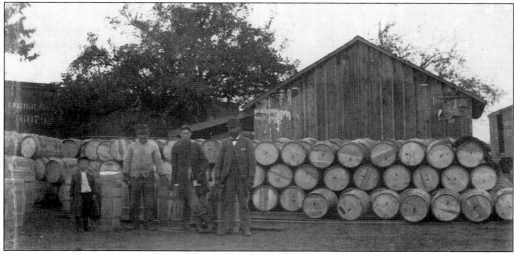

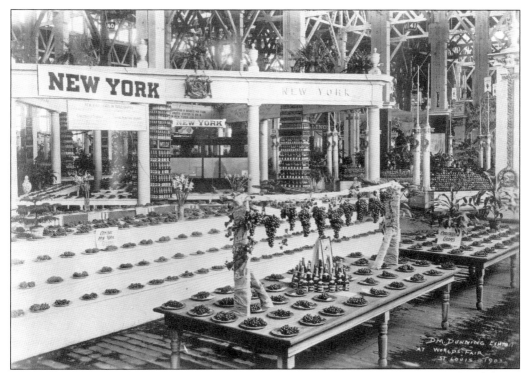

Here, Finger Lakes grapes adorn the shelves of D.M. Dunning's Grapes of New York exhibit at the 1904 World's Fair. According to the 1900 census, the Finger Lakes boasted 26,000 acres of vineyard, producing 50,000 tons of grapes worth $1 million annually. (FALL.)

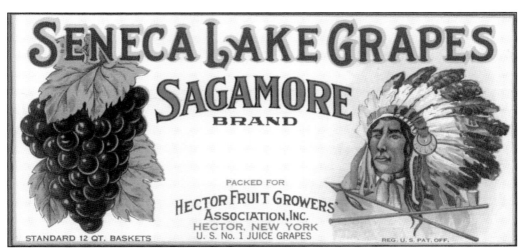

By the mid-1900s, increased competition had pushed grape packers and shippers into new markets; thus, the branded grape label was born. The Hector Fruit Growers' Association was a distributor of railcar lots of peaches and grapes on the east side of Seneca Lake. Its Sagamore Brand was patented in 1914. (GHCM.)

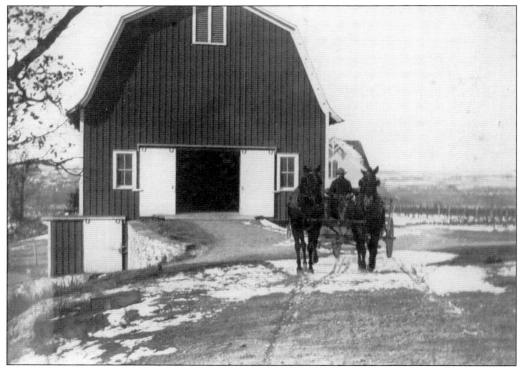

From 1915 to 1917, William Herbert Hazlitt was manager of the Hector Fruit Growers' Association. Born in 1879, he was the third generation of Hazlitts to farm in Hector on the east side of Seneca Lake. In the photograph above from the winter of about 1903, William drives the fruit wagon away from his newly rebuilt barn, with snow blanketing the ground and vineyards to the right. By this time, fruit and grape growing on the east side of Seneca Lake was booming. Below is the Hector Fruit Growers' Association storage facility on the LV around 1914. (Both, HV.)

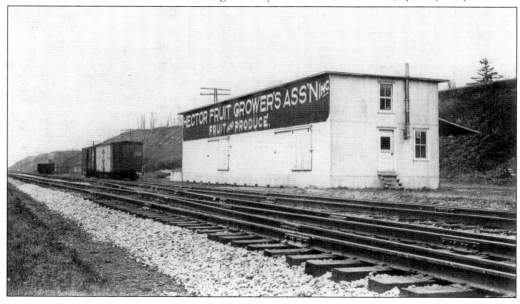

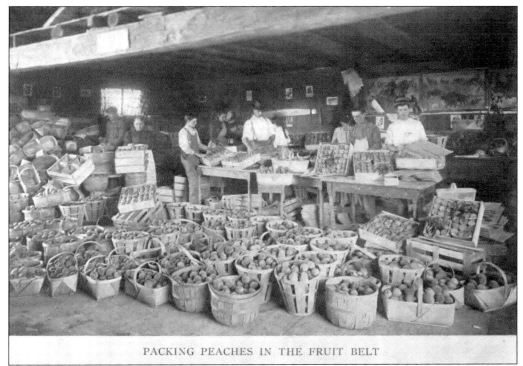

PACKING PEACHES IN THE FRUIT BELT

By the early 1900s, peaches had become the biggest crop for farmers on Seneca Lake's east side. When the LV came to Hector, it began shipping peaches, grapes, and berries to cities via special fruit cars. Accounts say it was common to ship 25 carloads per day during harvest. The area became known as "the Fruit Belt." In a 1911 brochure titled *Farming Opportunities Along the Lehigh Valley Railroad*, readers see photographs of thriving lakeside vineyards, busy packinghouses, and quaint bungalows alongside a listing of 50 farms for sale; the LV hoped to capitalize on what it called the "back-to-the-farm" movement. Above and below are photographs from the brochure, which also notes that, in one year, 20 million pounds of grapes were harvested in the Fruit Belt. (Both, HT.)

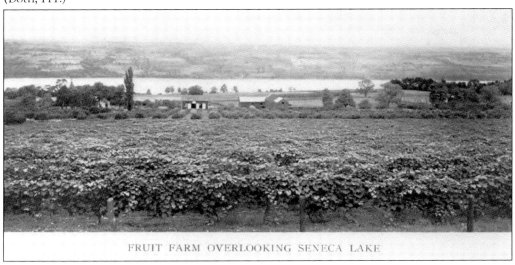

FRUIT FARM OVERLOOKING SENECA LAKE

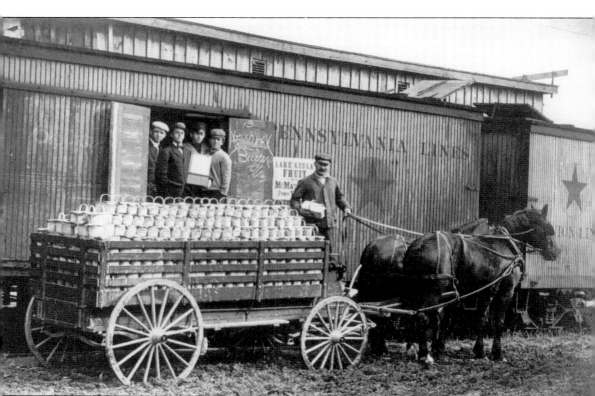

When the automobile burst on the scene around 1910, it marked the end of an era for the Finger Lakes table grape industry. As more people traveled and shipped by automobile, passenger and freight rail service dropped off; eventually, the trolley lines shut down and the last lake steamer, the *Mary Bell*, made her final run in 1921. The passage of national Prohibition in 1919 sealed the deal. An exemption to the law allowed each head of household to make 200 gallons of wine per year for home consumption. This created a market for bulk grapes, and growers now sold directly to truckers who bought grapes in boxes, trays, or bushel baskets. Packing and shipping companies like McMath & Morgan saw their markets shrink, then slowly dissolve. Here, workers pose for a postcard photograph while loading pony baskets at the McMath freight depot on the Northern Central line of the Pennsylvania Railroad in Penn Yan. (YCHC.)

Three

FROM VINEYARD TO CELLAR

Many workers were behind the scenes of Finger Lakes wine country in the late 19th and early 20th centuries: tying crews, pickers, cellar workers, winemakers, bottlers, nurserymen, and scientists. During this time, a movement was under way to systematize and modernize agricultural practices. This systematization included advanced classification of plant species, scientific analysis of growing conditions, and advances in hybridization—the purposeful crossing of different types within a species to select for desirable characteristics. This work took place in the lab and the fields, with many of these activities centered in Geneva, at the northern end of Seneca Lake. There, the New York State Agricultural Experiment Station (NYSAES) opened in 1882 as a state agency devoted to "promoting agriculture in its various branches by scientific investigation and experiment." In 1923, the NYSAES became part of Cornell University. From its earliest days, NYSAES scientists tested planting, training, and pruning methods for grapes and developed new ways to combat pests and grapevine diseases, like black rot and powdery mildew.

Since about 1862, Geneva also boasted a successful nursery industry. By 1902, the Geneva Chamber of Commerce had estimated that more than 3,000 acres in Ontario County were being used to propagate fruit and ornamental trees, vines, shrubs, and flowers. In Geneva, the combination of private and public interests focused on scientific agriculture was an indispensable resource for the region's grape growers and winemakers. The NYSAES published frequent bulletins for farmers, offering practical research-based advice. Finger Lakes winemakers benefited from these recommendations, as well as their own sweat equity.

Making wine is a relatively straightforward process, but one that is not always romantic or easy. It requires manual labor and long hours, along with often inclement weather. The following photographs explore early 20th-century viticulture and winemaking processes, showing the scale of production and realities of work from vineyard to cellar.

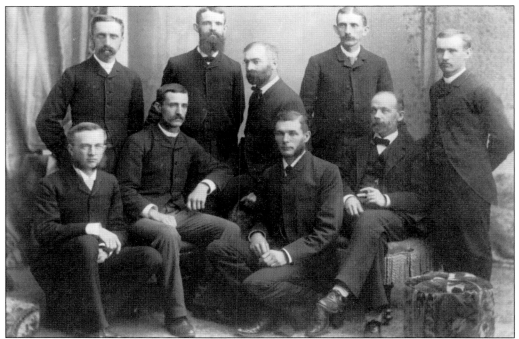

Above is an official photograph of the 1886 NYSAES staff. From left to right are (seated) F.E. Newton, stenographer; C.S. Plumb, first assistant; S.M. Babcock, chemist; M.H. Beckwith, assistant horticulturist; and E. Lewis Sturtevant, director; (standing) J.C. Arthur, botanist; E.S. Goff, horticulturist; C.W. Churchill, farmer; and E.F. Ladd, chemist. Below are the original NYSAES barns in Geneva around 1888. The structure to the right was a carriage house and horse barn; the station's old stone barn is immediately behind it. The circular forms in the foreground are lysimeters, which measure the amount of water that plants, trees, or crops release into the atmosphere; they were located in the lawn just west of Sturtevant Hall. (Both, FALL.)

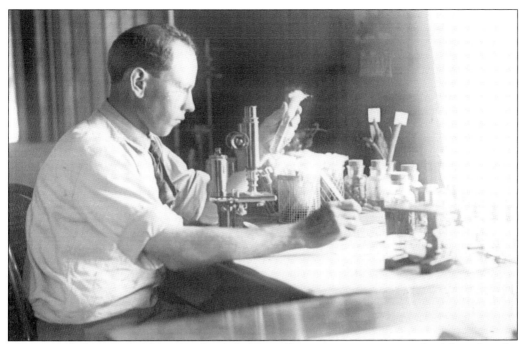

Above and below, entomologist Frederick Z. Hartzell examines specimens in his lab and in the field at the Fredonia experimental vineyard station around 1910. In 1909, the New York State Legislature funded the study of grape production in the Chautauqua-Erie district, a Concord-growing area along Lake Erie spanning counties in western New York and Pennsylvania; the NYSAES was appointed to do this work. The station managed a 20-acre experimental vineyard near its headquarters in Fredonia, and Hartzell was assigned there to study grapevine insect pests. During his time in Fredonia, Hartzell developed treatments to fight the grape leafhopper, berry moth, rootworm, steely beetle, and rose chafer. (Both, FALL.)

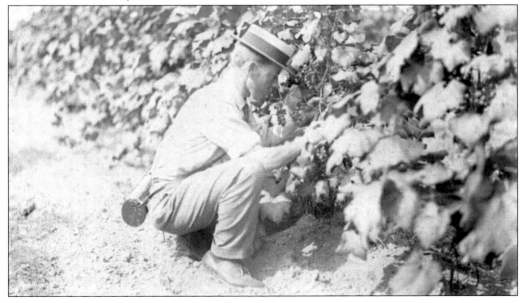

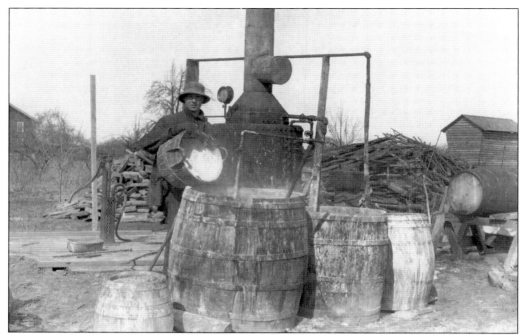

Initially, Hartzell was focused on eradicating the grape rootworm, a pest that, in 1909, was devastating vineyards in the Chautauqua-Erie region. Above, a station worker cooks lime sulfur around 1905. Lime sulfur is made by mixing precise measurements of calcium hydroxide with sulfur, then boiling the two together with a small amount of emulsifier. Lime sulfur is believed to be the earliest synthetic chemical pesticide, first used in France in the 1840s to control grapevine powdery mildew. Generally, it was used as a spray, having a reddish-yellow color and foul odor. Below, a worker uses a horse-powered Victor sprayer to treat vineyards in Fredonia around 1910. (Both, FALL.)

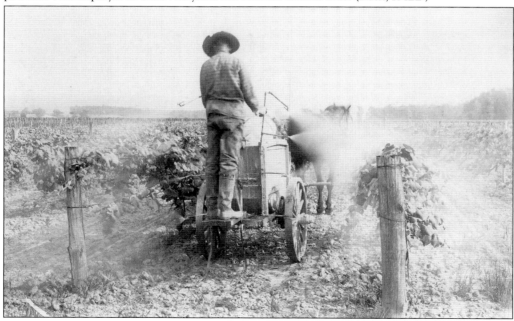

In 1853, Thompson C. Maxwell and his brothers Henry and Joshua formed the firm of T.C. Maxwell & Brothers. By 1878, their nursery, covering 500 acres, had become known for its large stock of standard and dwarf pear, cherry, plum, and quince trees. At right, Henry Maxwell poses with a dwarf cherry tree at his residence around 1880. R.G. Chase & Company was another Geneva nursery, founded in 1866 to sell directly to growers. Below, workers at the R.G. Chase packing shed bundle nursery stock and assemble wooden crates for delivery in the 1860s. (Photographs by James G. Vail, 1842–1929; both, GHS.)

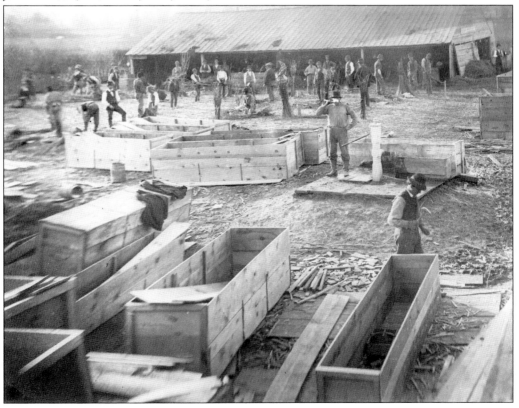

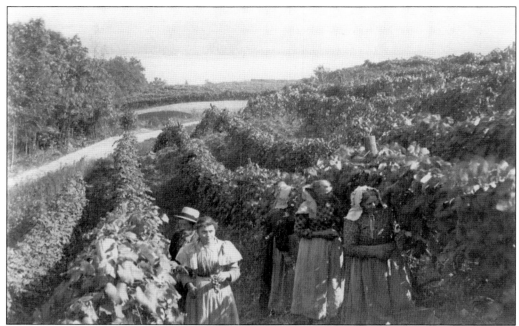

Harvesting and packing grapes was exclusively women's work. Above, women harvest grapes at the Urbana Wine Company around 1900. The lone man is likely the foreman or vineyard manager. Below, workers pose for a staged photograph during harvest at the Empire State Wine Company's vineyards in Penn Yan, also around 1900. The company's main building was located on the south shore of Keuka Lake, near the entrance to the Keuka outlet. Women filled the wooden grape trays and left them at the end of each row; men collected the trays, then loaded and transported them to the winery for processing. (Above, GHCM; below, YCHC.)

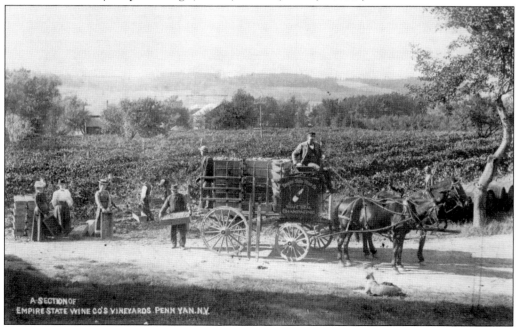

A SECTION OF
EMPIRE STATE WINE CO'S VINEYARDS. PENN YAN. N.Y.

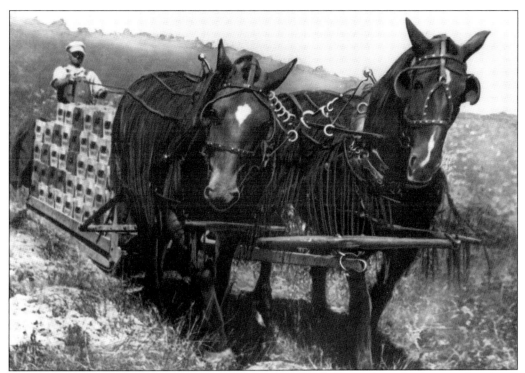

Harvest season was a flurry of activity. After grapes were picked, men brought them to the winery for pressing. Above, a horse-drawn sledge (or stoneboat) brings grapes down from Widmer's Wine Cellars' hillside vineyards to the winery in Naples around 1900. Loaded wagons would have sped out of control down the steep slopes. Below, carts bearing grape trays line up outside Widmer's winery building for unloading around 1890. Each tray held 30 pounds of grapes; these carts could likely transport up to 80 trays, or 2,400 pounds, of grapes per trip. (Above, FLM; below, RCC.)

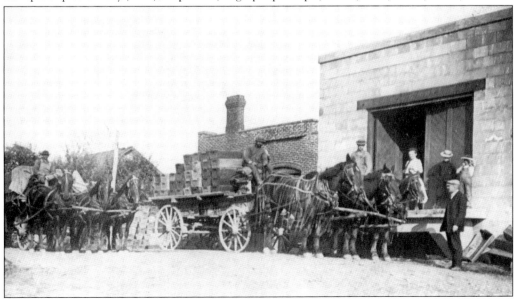

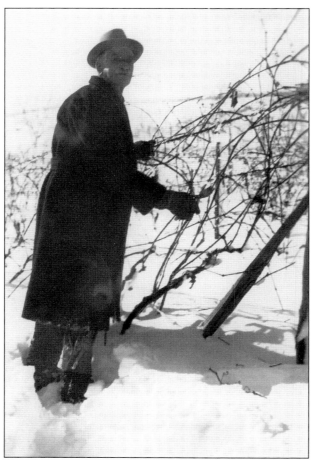

Vineyard work does not end at harvest. Winter pruning is usually done between mid-December and March, ensuring proper spacing between new vine shoots and the right amount of fruiting wood (or buds) to produce the quality crop desired for next year's vintage. At left, Gottlieb Glauser, age 81, prunes in the snow at Widmer's vineyards around 1946. A year later, Gottlieb celebrated 40 years of working at Widmer's as a vineyard specialist. He emigrated from Switzerland to the United States in 1884, first to Ohio and then to Bluff Point on Keuka Lake, where he learned viticulture. Below, Gottlieb (left) and a colleague carry hand pruners (*sécateur* in French) and pruning saws. (Both, RCC.)

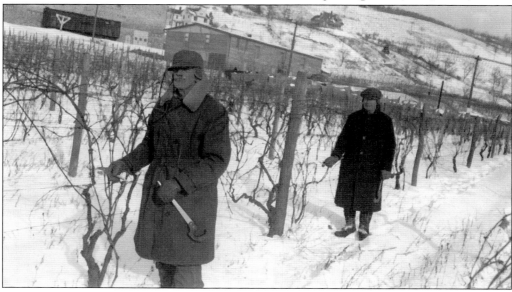

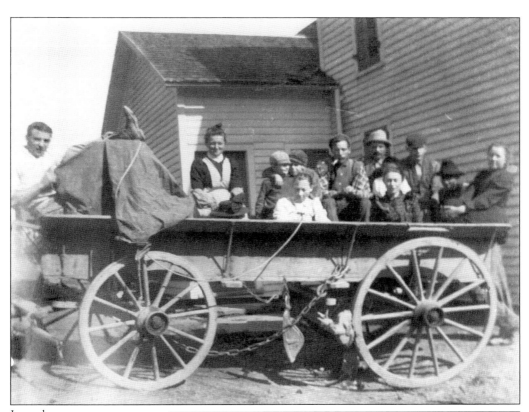

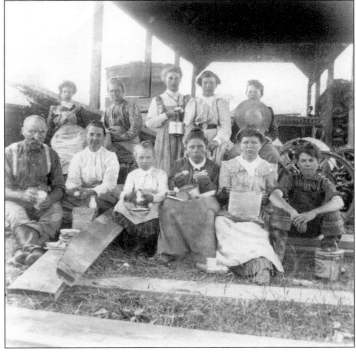

In early summer, many growers (depending on the system they use to train their vines on vertical trellises) will thin and tie their vines. Vineyard workers select a certain number of healthy trailing vines, cut back the rest, then trim and tie the remaining ones to the trellis wire to stay in place. Today, tying is done using twine. In the 1900s, rye straw or something similar was often used. Above, a gang of Widmer grape tiers gets ready to start work on Rhine Street (County Road 12 in Naples today). At right, Widmer workers of all ages break for lunch during summer straw tying around 1900. (Both, RCC.)

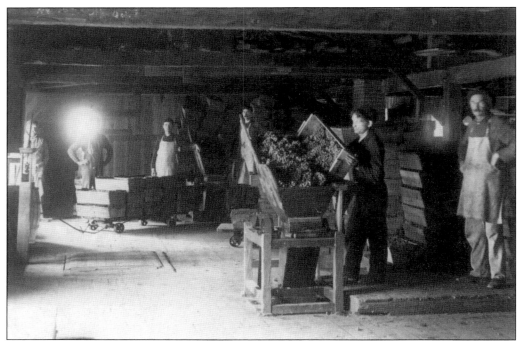

Above, at an unidentified Keuka Lake winery, harvested grapes received at the winery are being fed into the hopper of a mill (or crusher) around 1900. The grapes are crushed and delivered via a chute to presses below. Below, at the Pleasant Valley Wine Company, two massive hydraulic rack-and-cloth wine presses extract juice from crushed grapes around 1915. The crushed grapes are laid in layers on cloth-covered racks, with up to 10 layers in each press. The presses then apply 350 tons of steam pressure to the pulp to extract the juice. Note the chutes extending down from the crushing room above. (Above, YCHC; below, GHCM.)

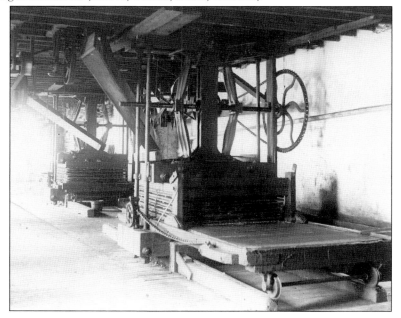

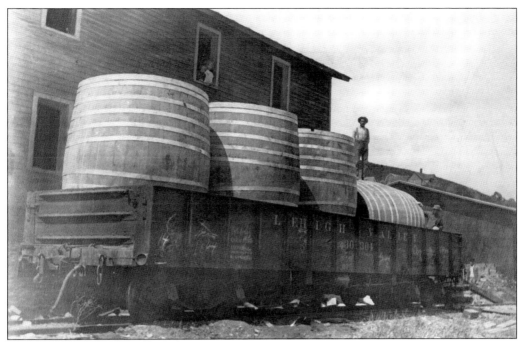

Until about the early 1960s, wooden casks were the only containers winemakers used for fermenting and storing their wines. Above, three workers unload empty oak casks from an LV railcar next to Widmer's Wine Cellars around 1900. Note the two small children watching the action from a second-story window. Below is a 1940s postcard showing these huge 3,500-gallon casks inside Widmer's cellar. One cask contains more than 17,000 bottles of wine. The smaller barrels hold about 50 to 60 gallons of wine; they are the most common size used by wineries today for aging wine. (Above, FLM; below, RCC.)

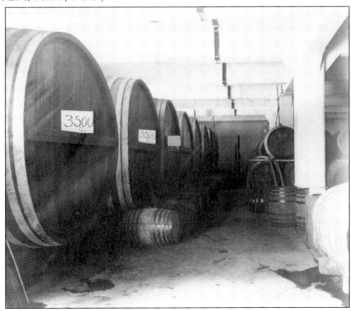

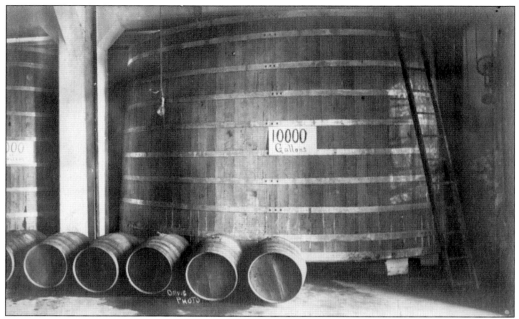

Imagine being a cellar worker at Widmer's Wine Cellars, filling and cleaning these 10,000-gallon straight-sided oak tanks. The tanks, seen above in a photograph from the 1940s, were probably used for fermenting grape must (juice from the crushed grapes and sometimes their skins) into wine. Workers climbed the ladder to monitor the fermentation process. (RCC.)

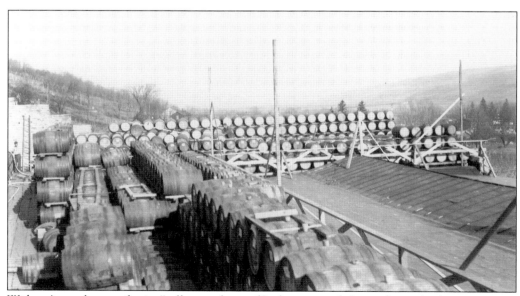

Widmer's was known for its "cellar on the roof," where it used the traditional solera process to make sherry, a sweetened fortified wine. The method entails blending a small fraction of the oldest vintage into each successive vintage, after a specific aging period. Here, the worker on the far left is topping up a barrel. (RCC.)

Here, a laboratory worker at the Empire State Wine Company in Penn Yan tests the winery's Vineyard Queen brand wines in the 1930s. Running simple chemical analyses, like testing sugar and acid levels, is an important part of winemaking. The company had been making this brand since at least 1900. (GHCM.)

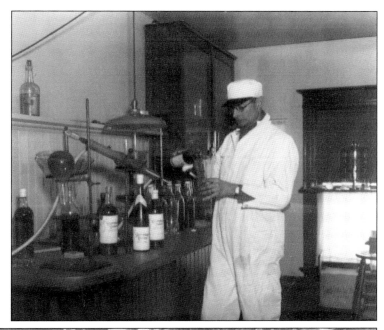

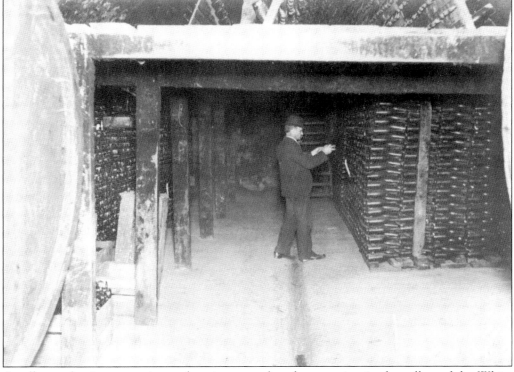

A cellar worker inspects wine undergoing secondary fermentation in the cellars of the White Top Champagne Company on Keuka Lake around 1900. Once fermentation is complete, these wines are destined for wooden riddling racks, the bottoms of which can be seen resting on the floor above. (GHCM.)

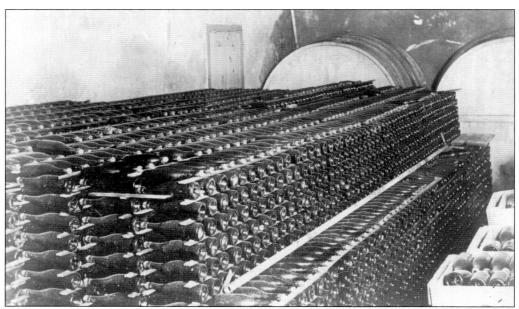

Early Finger Lakes wineries made sparkling wine using the *méthode champenoise*. First, sugar, yeast, and yeast nutrient are added to the cuvée (a blend of still wines) to create the tirage. This mixture is then bottled, stoppered, and laid horizontally to re-ferment, a process called *en tirage*. As it does, carbon dioxide builds inside the bottles and yeast cells (or lees) settle to the bottom, clarifying the now carbonated wine. After *en tirage*, bottles are placed in riddling racks at a 45-degree angle, where every day, over weeks or months, they are turned and then replaced at a slightly steeper angle until reaching 90 degrees. Riddling consolidates the lees into the neck of the bottle. Above are thousands of bottles *en tirage* at White Top; below are workers riddling wine in a Penn Yan cellar in the 1890s. (Above, GHCM; below, YCHC.)

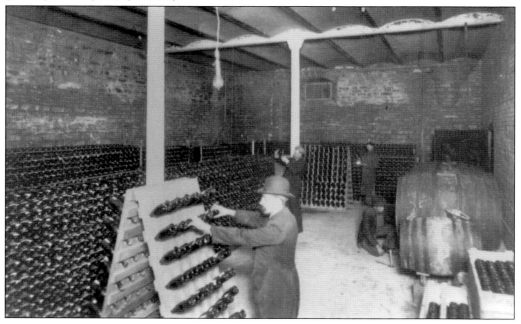

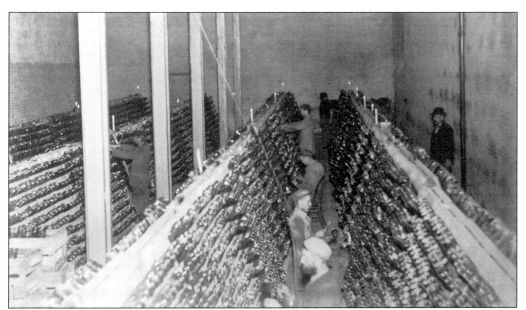

Above are White Top workers riddling sparkling wine by hand in a cellar lit only by small gas lanterns and candles. After riddling, the lees are carefully disgorged from the bottles, a varying amount of sugar (the dosage) is added, and the bottles are corked. A wire bail is placed over the cork to prevent it from popping under pressure. As seen in the photograph below of the Taylor champagne bottling line in 1938, not much of this process had changed since the 1880s (see page 17). Below, from right to left, Faye Sherman disgorges the bottles, George Silliman adds the dosage, Francis Smalt uses a floor corker, Frank Hamilton attaches the wire bail, and Frank Rice inspects bottles for clarity. (Both, GHCM.)

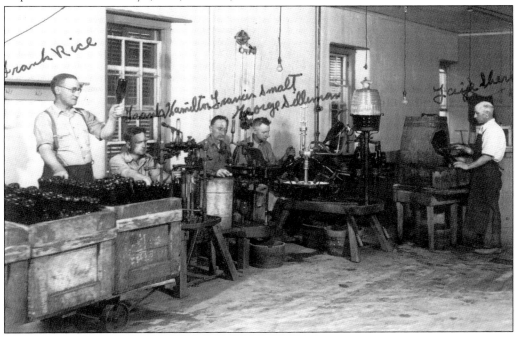

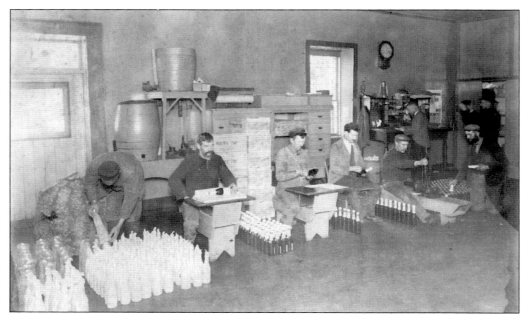

In December 1899, the White Top Champagne Company was bustling. Above, working from right to left, one worker examines the bottles, one places foil caps while another seals them, two attach labels, and one wraps bottles in paper while another adds a protective straw cover. Below, in this rare informal photograph, the dirty work of bottling wine is presented in all its glory at an unidentified Keuka Lake winery around 1900. Hoses lie on the floor, which is covered in wine. Workers hover with empty carriers to fill. Two men in the middle use tall champagne corking machines, while the man at left appears to be securing wire hoods. It is hot work; a young man in the back corner breaks for a refreshing swig. (Both, YCHC.)

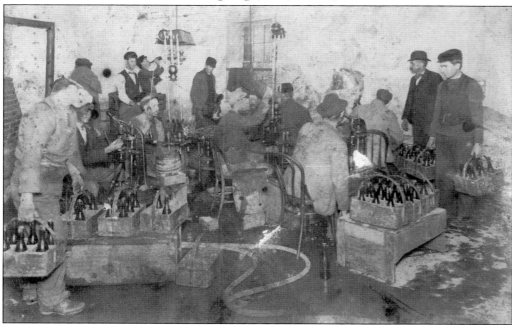

Four

TEMPERANCE
AND TENACITY

The late 19th century was a hotbed of social and political reform movements in the United States. Many of these were focused in central and western New York, including the Finger Lakes district. The first was the Second Great Awakening, a Protestant revival movement that sought to correct society's evils in anticipation of the Second Coming of Jesus Christ. This movement was so strong in the Finger Lakes that the region became known as the "burned-over district," with large groups dedicated to ridding society of its sins. Such sins included social inequality, slavery, drunkenness, and domestic violence.

Throughout the 1800s, abolitionist sentiment grew in towns like Waterloo, Geneva, and Seneca Falls. Antislavery petitions were signed, societies formed, and political candidates endorsed. When the Fugitive Slave Act took effect in 1850, abolitionists in the region aided runaway slaves through the Underground Railroad. The women's rights movement grew alongside abolitionism in the Finger Lakes. In July 1848, Elizabeth Cady Stanton and Quaker abolitionist Lucretia Mott organized the Seneca Falls Convention on the west side of Cayuga Lake. From the start, suffragists promoted social reforms beyond the vote, including prohibition of alcohol. The idea was that limiting alcohol consumption would cut down on domestic abuse. Soon, large numbers of women joined the American temperance movement. The crusade started as a move toward moderation; it ended in the final passing of federal Prohibition in 1919.

The Eighteenth Amendment banned the commercial production and sale of all intoxicating liquor. Prohibition devastated most Finger Lakes wineries. The survivors did so by making legal sacramental wines, along with juices, jellies, and sauces. The nation's "noble experiment" ended in 1933, but by then, it had irrevocably changed the Finger Lakes grape culture. Small vineyards were ripped out or replanted to juice varieties, like Concord and Niagara. By 1932, vineyard acreage had dropped, and grape prices fell below production prices. At the NYSAES in Geneva, grape-breeding research remained centered on table and juice varieties; the station would not initiate another major wine research program until 1955.

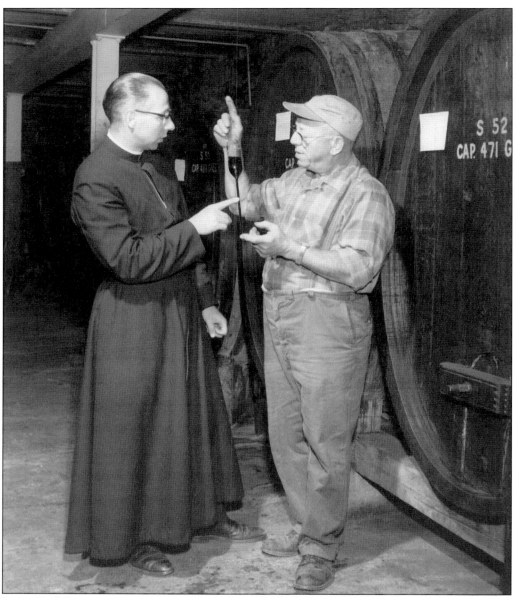

Before Prohibition, many wineries in the Finger Lakes had a long tradition of producing sacramental wines. One of the oldest sacramental wineries in the region is O-Neh-Dah Vineyards on Hemlock Lake, a minor Finger Lake south of Rochester in Livingston County. In 1872, Bernard McQuaid, bishop of the newly formed Roman Catholic Rochester Diocese, planted his own vineyards on the lake to ensure a source of sacramental wine for his churches. After McQuaid's death in 1909, the Society of the Divine Word, a Dutch Missionary order, took over production. Here, Fr. John Musinsky of the Society of the Divine Word examines a barrel sample with winemaker Leo Goering, a German immigrant who resurrected O-Neh-Da in the late 1930s. Oddly enough, though wineries could obtain special permits for legally making and selling sacramental wines during Prohibition, O-Neh-Da instead opted to cease operations. The winery continues to produce sacramental wines today. (FLM.)

Widmer's Wine Cellars was well positioned when Prohibition took effect. The company had been making grape juice since 1912, so it had the capacity necessary to manufacture and bottle a wide array of grape products. Widmer changed its name to the Widmer Grape Products Company to reflect the new laws. During Prohibition, every conceivable product that could be made from grapes was produced by Widmer: altar and medicinal wines; wine tonics and sauces; grape jellies, syrups, and concentrate; and rum and brandy sauces and jellies. Above is a Prohibition-era Widmer grape crate label. Below, workers at the Widmer juice plant load barrels onto a horse sled around 1919. (Above, YCHC; below, NPL.)

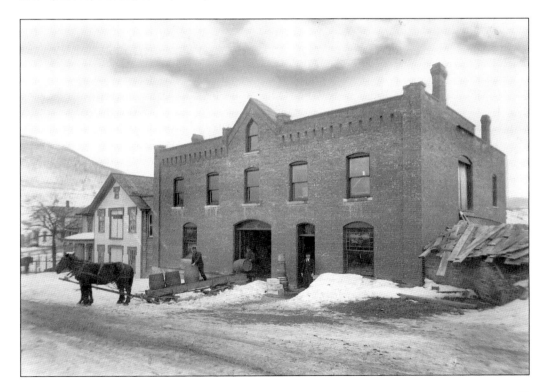

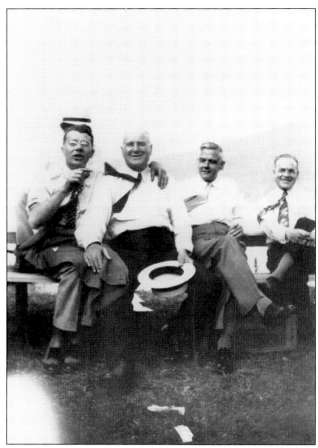

The Prohibition-era grape juice business was competitive yet collegial. In August 1932, the Finger Lakes Grape Juice companies hosted the Chautauqua Belt and Ohio Packers of Grape Juice for a weekend of socializing and strategizing. According to the *Naples News*, these packers produced over two-thirds of the grape juice sold in the United States at the time. They assembled first at the Widmer juice factory for lunch on the lake. There, four big players paused for the photograph at left. From left to right are D.W. Putnam of the D.H. Putnam Company, Hammondsport; William Riley of United Grape Products, Inc., Buffalo; Nathaniel Taft of the American Grape Juice Corporation, Fredonia; and W.A. Petrie, also of United Grape Products. Below, Widmer workers load five-gallon earthenware juice jugs in the 1930s. (Left, RCC; below, FLM.)

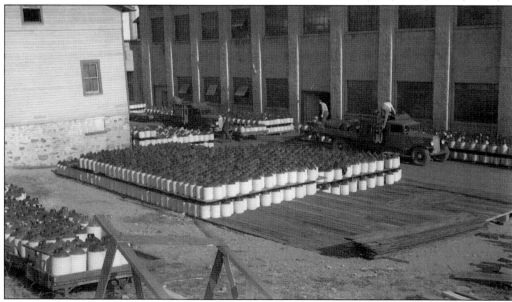

The Taylor Company in Hammondsport also was well equipped to diversify during Prohibition. As Prohibition dragged on, many wineries began selling juice to home winemakers since a special exemption of the Volstead Act allowed heads of households to make up to 200 gallons (roughly equivalent to a thousand 750-milliliter bottles) of "non-intoxicating cider and fruit juice" at home for personal consumption. However, the IRS did not define "intoxicating" using alcohol percentage, so homemade wines could contain over 0.5 percent alcohol. At right are Taylor's wine-grape juices aging in barrels. In its Prohibition-era brochure below, Taylor offers consumers juices for making wine in 10-, 15-, and 20-gallon kegs or 30- and 50-gallon barrels. What could be more convenient for the 1920s home winemaker? (Both, BHV.)

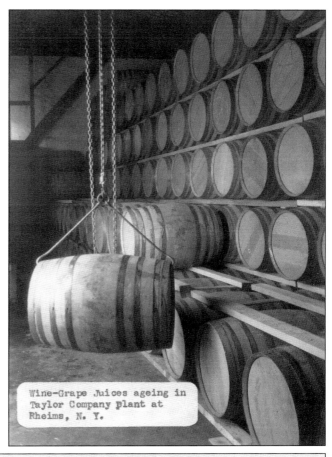

Wine-Grape Juices ageing in Taylor Company plant at Rheims, N. Y.

AFTER THE PAINTING
BY W. DENDY SADLER

WM. A. STRAUB & CO.
40 W. Lockwood Ave.
Webster Groves, Mo.

Webster 170

"The Seal of Satisfaction"

The
TAYLOR COMPANY
HAMMONDSPORT,
NEW YORK

© The Taylor Co., 1930

TAYLOR'S
Wine-
Juices

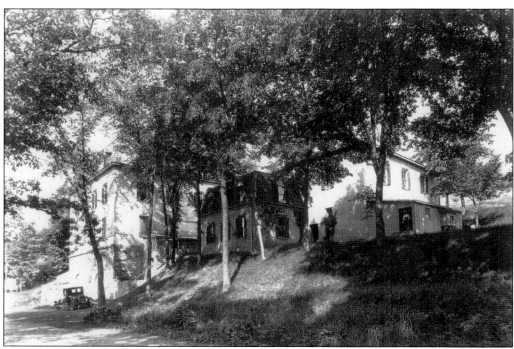

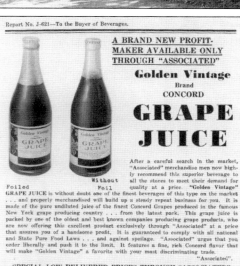

As Prohibition emerged, the Taylor Wine
Company became simply the Taylor
Company. In 1920, Walter Taylor purchased
the Columbia Wine Company from
Seymour Hubbs. At the time, many local
wineries were getting out of the business,
believing Prohibition tolled the death
knell of the industry. Taylor instead saw
it as an opportunity. Above, the facility
in Hammondsport was larger and more
modern, allowing a well-timed expansion
of Taylor's grape juice production and
aggressive advertising of "wine-types" for
home winemakers. At left, Taylor's Golden
Vintage grape juice was marketed as a
store brand for Associated Department
and General Stores. (Both, BHV.)

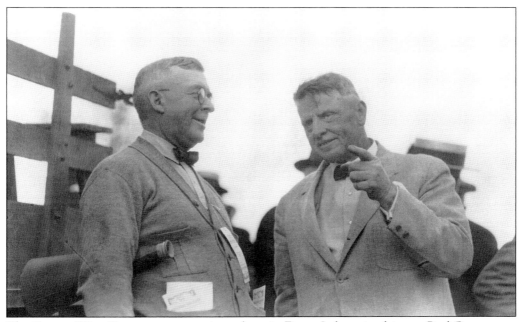

The Garrett Wine Company was a unique player in Finger Lakes wine history. Paul Garrett was from an old North Carolina winemaking family. By 1915, Garrett had fled north to Penn Yan to escape the encroaching "dry movement." There, he opened a winery and continued producing his nationally popular Virginia Dare wine, made from the native scuppernong grape. As Prohibition dawned in 1919, Garrett expanded his Penn Yan plant to make grape jam, jelly, and juice. He also made dealcoholized wine, using the alcohol to produce what Joy Holland refers to in "Days of Wine and Onions: Garrett & Co. and Virginia Dare" (on *Brooklynology.org*) as "pure fruit and vegetable flavorings" at his separate Brooklyn-based company. The Virginia Dare Extract Company still exists today. Above, Paul Garrett (right) talks with Walter B. Tower, 1910 chairman of the Yates County Board of Supervisors. Below is the Garrett building on Liberty Street in the 1930s. (Both, YCHC.)

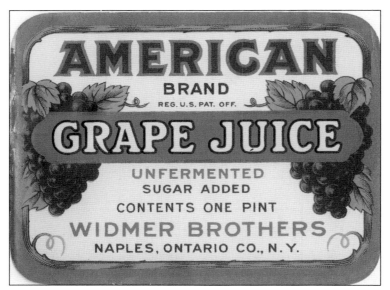

When Prohibition took effect, Widmer's Wine Cellars had been making pasteurized grape juice for seven years. At left is a label for the Widmer Brothers American Brand juice, likely from 1924. That year, founder John Jacob Widmer sold the winery to his sons Carl, Frank, and Will—the Widmer Brothers. (EWGA.)

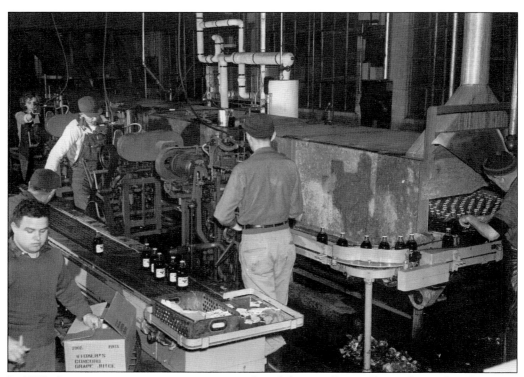

In 1920, American grape juice companies produced three million gallons of juice, but they were saddled with higher production costs and added taxes. Soon, cheaper soft drinks started eroding the juice companies' market share. Here, workers at the Widmer Grape Juice plant manage a steady flow on the automated bottling line. (RCC.)

One of the beverages competing with grape juice was Grape-Vinar. Made by the Taylor Company, the grape-based soft drink was described as "an absolutely pure, clear, sparkling and unfermented drink" without preservatives or added sugars. This sign advertises Grape-Vinar's availability on tap at a local soda fountain. (BHV.)

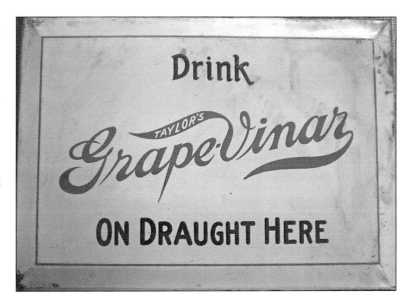

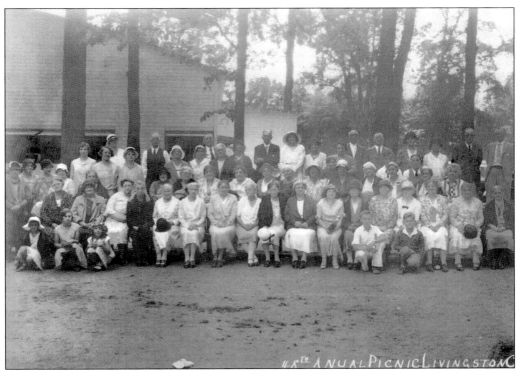

In 1873, the Woman's Christian Temperance Union (WCTU) was founded in Fredonia, New York. The WCTU fought to ban alcohol sales across the country and supported the Eighteenth Amendment. With repeal on the horizon, members of the Livingston County WCTU pose at their 48th annual picnic in 1931. (GHCM.)

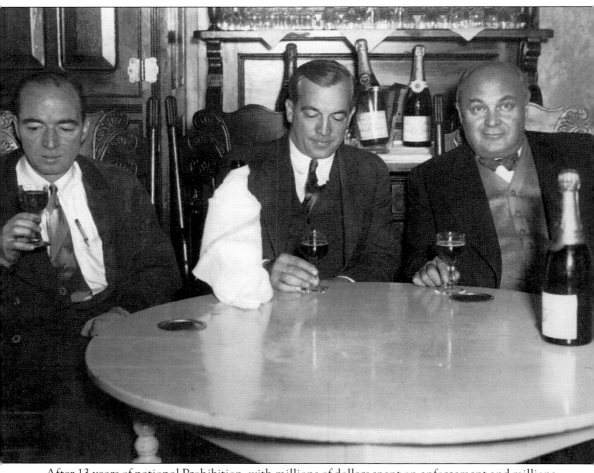

After 13 years of national Prohibition, with millions of dollars spent on enforcement and millions lost in tax revenues, Congress repealed the Eighteenth Amendment on December 3, 1933. In Finger Lakes wine country, repeal was greeted enthusiastically but wearily. In Hammondsport, the Champlin family celebrated at Pleasant Valley Wine Company with, of course, several bottles of their Great Western champagne on ice. Pictured are the "three gentlemen," as they are referred to on the back of this photograph—(from left to right) Frances Malburn Champlin, Charles D. Champlin II, and James "Jim" Bauder, who was son of Dewitt C. Bauder, founding secretary and treasurer of Pleasant Valley Wine Company. He also was Frances and Charles's first cousin; all three are grandsons of winery founder Charles D. Champlin. The business survived Prohibition—and maintained its reputation—by making sparkling sacramental wines and unfermented juice. After repeal, Pleasant Valley would bounce back, with the Champlin family retaining control until 1955. (GHCM.)

Five

COMEBACK AND CONSOLIDATION

With repeal, the remaining Finger Lakes wineries geared up to make wine once again, but Prohibition had dramatically changed the wine industry and consumer tastes. In California, it had actually opened new markets; growers sent railcars of fresh grapes destined for eastern home winemakers, and some wineries even sold wine to European wineries for blending. Unfortunately, Finger Lakes winemakers were not so lucky, especially once the Great Depression set in. First, their most well-known product, sparkling wine, was labor intensive and expensive—not a workingman's drink or one easily made at home. Also, the federal government had not included champagne on its list of legal sacramental wines. To protest, Urbana Wine Company filed a lawsuit in 1927 and won; two years later, the government included all champagne producers on the list, but by then, the damage was done.

After Prohibition, consumer tastes leaned toward sweet, high-octane beverages. An entire generation had grown up on bathtub gin and liquor cocktails, and sweet fortified wines would continue to dominate consumer sales until the late 1950s. The main reason for this was that, during Prohibition, wineries had focused more on selling "good-looking" bulk grapes and less on growing wine grapes. With not enough good wine grapes, or a market for better wines, Finger Lakes wineries after repeal would focus on making what a 1934 *Fortune* magazine article says "the U.S. most wants . . . strong, fortified wines of the sherry, port, muscatel types."

In January 1937, of the wineries on Canandaigua and Keuka Lakes, 19 still held licenses; none existed on Seneca and Cayuga Lakes. Soon, weaker players foundered and stronger ones swooped in to consolidate. By 1965, only seven wineries remained in the Finger Lakes. However, those wineries did their best to raise the region out of Prohibition's shadow by experimenting with new grape varieties, making new products, and promoting a new concept—marketing wine by its grape variety.

The Garrett Wine Cellars storage building, seen from Penn Yan's Water Street bridge, was badly damaged in a July 1954 storm. By this time, Garrett was making all its wines in Brooklyn from out-of-state grapes; only Garrett's sparkling wines were made from Keuka Lake grapes. In 1965, Canandaigua Wine Company purchased the winery. (YCHC.)

Workers process grapes at the Putnam Company plant in Hammondsport in September 1955. During Prohibition, the company operated primarily as a grape-packing firm. After repeal, it resurrected the former Hammondsport Wine Company and began making Gold Seal champagne again. In the 1970s, Canandaigua Wine Company bought the company. (Photograph by P.B. Oakley [c. 1910–1971]; GHS.)

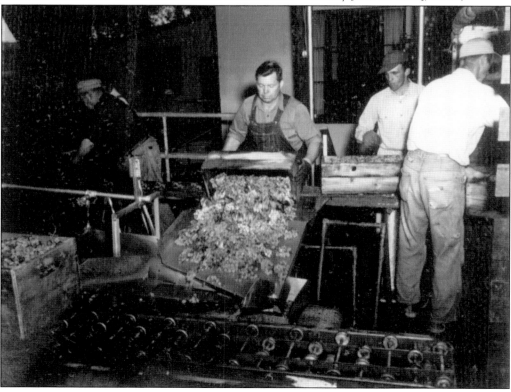

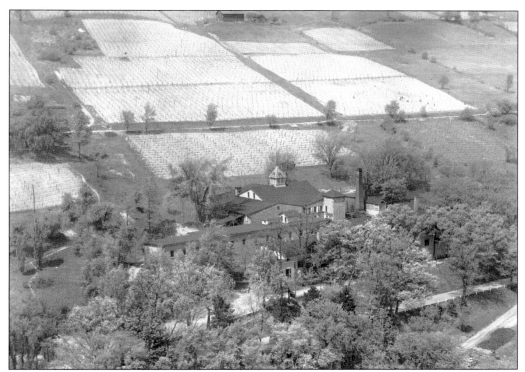

The Pleasant Valley Wine Company in Hammondsport survived Prohibition by selling sacramental and medicinal wines. Production grew steadily after repeal—especially the winery's signature Great Western champagne. Pleasant Valley had been known for its sparkling wines since about 1873, when Great Western champagne became the first American sparkling wine to win first prize in a European competition; several more awards followed. Above is an aerial view of the winery's facilities around 1950, while the postcard below gives an idea of the scale of Pleasant Valley's sparkling wine production at the time. Here, approximately 100,000 bottles of sparkling wine are undergoing secondary fermentation. (Both, GHCM.)

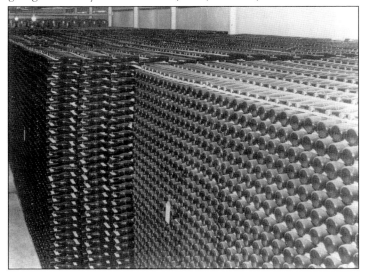

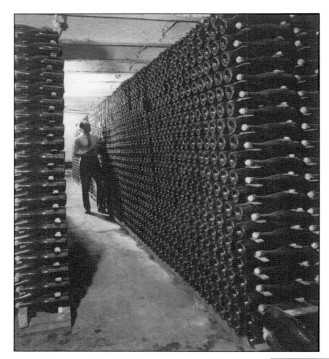

William D. "Tony" Doherty, vice president and general manager, examines 250,000 bottles of champagne in the Pleasant Valley cellars in June 1951. Born in 1917, Tony is the great-grandson of Pleasant Valley founder Charles D. Champlin I. Tony also is the father of Trafford Doherty, current director of the Glenn H. Curtiss Museum. (GHCM.)

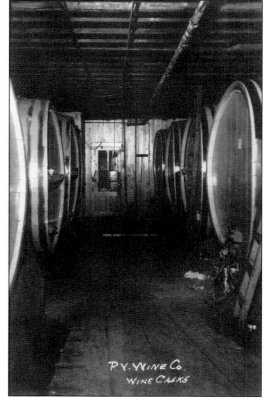

This is an original real-photo postcard showing Pleasant Valley's cellars, where still wine is stored in American oak casks, each holding approximately 1,200 to 1,500 gallons. Pleasant Valley's immense wine and champagne cellars were a popular subject of postcards in the late 1940s and early 1950s. (GHCM.)

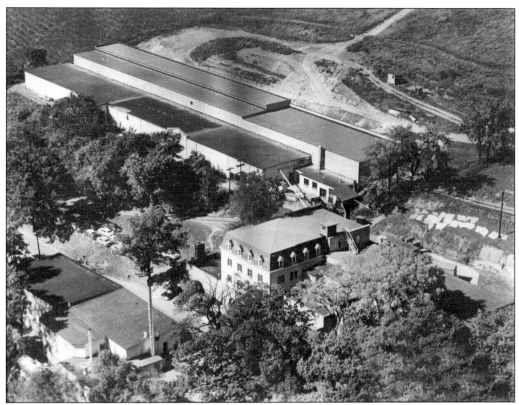

After repeal, the Taylor Wine Company name returned and so did its production. The company continued to sell wines made from native grapes often blended with juice from California, a common practice among large eastern wineries at this time. In 1953, Taylor embarked on a major expansion. Above is an aerial photograph showing the new buildings being constructed next to and behind the original winery in the foreground. Fortified and dessert wines were a traditional product made by the earliest Finger Lakes winemakers. Taylor was no exception, as the company was known for its ports and sherries. Below are two vintage Taylor labels, probably dating from 1939 to 1950. (Both, BHV.)

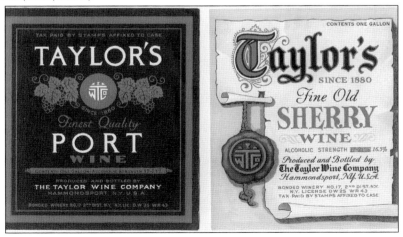

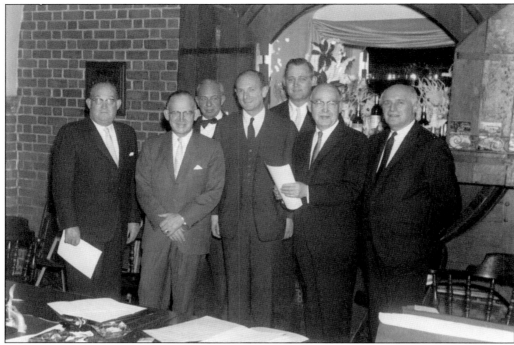

In 1961, the first major consolidation took place in the Finger Lakes wine industry. The Taylor family took its company public, selling shares to finance the purchase of Pleasant Valley Wine Company and further expand the business. Above, the major players pose after the transaction is final. They are, from left to right, Greyton Taylor, Clarence Taylor, unidentified, Marne Obernauer (president of Pleasant Valley), Walter S. Taylor, Fred Taylor, and unidentified. From 1957 to 1961, Walter Taylor worked under his father, Greyton, in public relations and advertising. In 1961, he became assistant managing director of newly acquired Pleasant Valley. Below, Walter inspects the Great Western bottling line. (Both, BHV.)

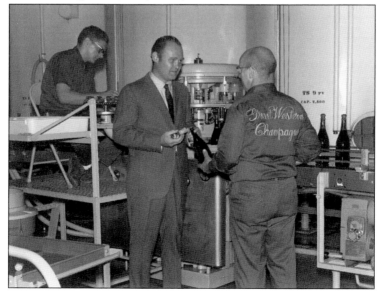

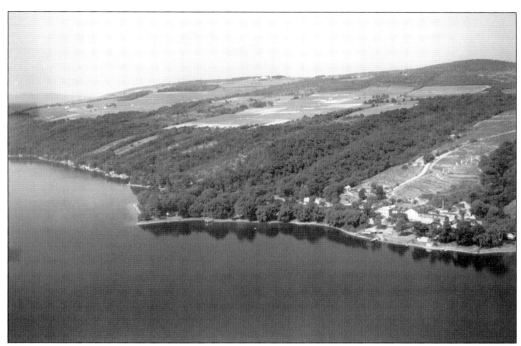

With repeal, owner E.S. Underhill reopened Urbana Wine Company and, in 1933, hired away Charles Fournier from Veuve Clicquot Ponsardin to become the latest in a long line of French winemakers imported from the Champagne region to make wine for Urbana. Fournier used native grapes but continually sought improvement. In 1944, he planted one of the first commercial vineyards of French American hybrid grapes in the United States on the shores of Keuka Lake. These hybrids were developed in France by crossing native American species with European vinifera. In 1957, Urbana was renamed Gold Seal Vineyards; above is an aerial view of Gold Seal's vineyards around 1961. Below, Fournier (right) and an unidentified guest enjoy the grand opening of Wagner Vineyards in 1979. (Above, YCHC; below, WV.)

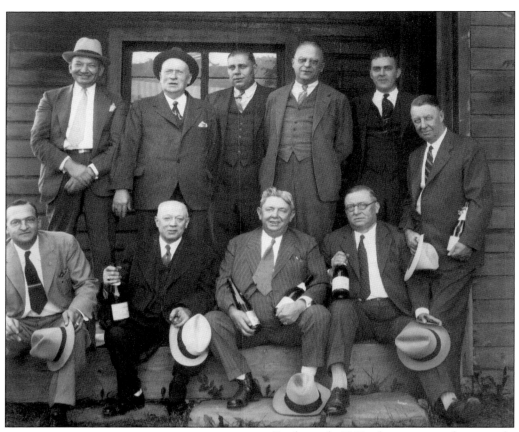

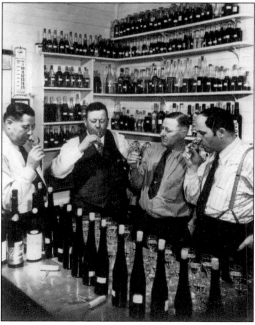

By the early 1940s, four wineries dominated the Finger Lakes region—Taylor, Great Western, Gold Seal, and Widmer. Widmer emerged from Prohibition ready for expansion. As production picked up, the company's sales team was ebullient, as seen above. At left, an intense tasting takes place at Widmer's Wine Cellars in March 1941. This was the year the company introduced its first wine labels bearing the names of the grapes used to make the wines. In November 1941, wine importer Frank Schoonmaker listed 10 of them in his seminal *American Varietal Wines* catalog, including Lake Catawba, Lake Diana, Lake Vergennes, and Lake Isabella. The concept was revolutionary at the time; today, varietal labeling is the industry standard. (Both, FLM.)

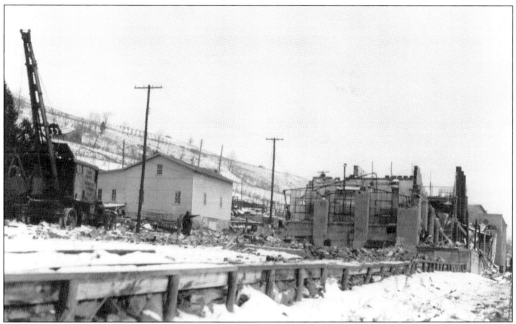

On January 23, 1943, disaster struck the Widmer juice plant and winery. The January 27, 1943, *Naples Record* calls it the "costliest fire in Naples' history," reporting that the blaze destroyed the winery's power and water-filtering plants, grape juice cellar, bottling machinery, storage sheds, and original brick wine cellar built in 1888. Above is a photograph of the gutted juice plant (right), while below is a view of the damaged brick wine cellar seen beyond the rooftop sherry barrels. In the *Naples Record* story, William Widmer, winery president, assures readers that "none of his employees need seek other employment, as there is, and will be, work for all." (Both, RCC.)

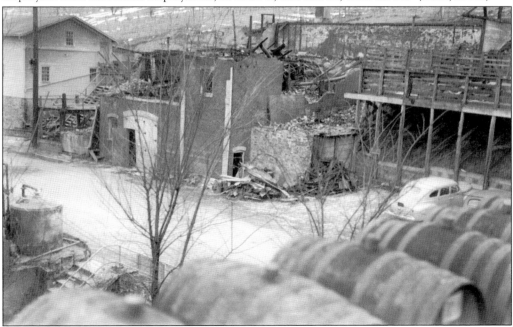

Widmer bounced back after the fire, and by the 1950s, a collection of 200 barrels of sherry was aging on the winery's roof. At left, a daring barrel jumper adds to the stack. Stacked four deep, the barrels below were estimated to cover six acres if spread out. Maintaining the solera at Widmer meant continually adding new barrels to the stacks. Sherry is transferred from top to bottom, with the oldest barrel, also called the solera, on the ground level. Each successive level is topped with sherry from the newer barrels so that each barrel now contains a fractional amount of the older sherries. Bottling is done using a portion pulled from the oldest barrels. (Both, FLM.)

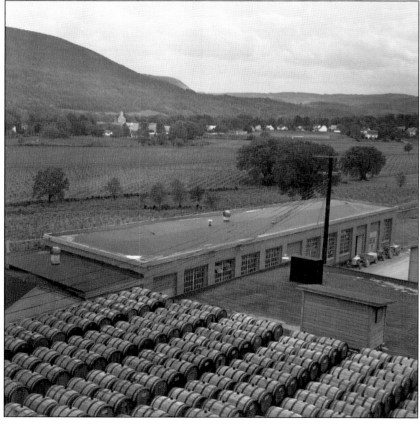

By the early 1960s, tourism and winemaking had joined forces again. In October 1961, the town of Naples on Canandaigua Lake hosted its first-annual Grape Festival. The event was based on the area's long history and pride in viticulture and winemaking. At right is the original 1961 festival brochure. (NPL.)

The Naples Grape Festival is the closest thing to a harvest festival in the region. It featured a parade, floats, marching bands, baking contests, and grape judging. Naples is Widmer's Wine Cellars' hometown, and in the 1963 parade, the winery proudly showed off its float celebrating 75 years in business. (NPL.)

The Naples Grape Festival was a popular attraction. Here, a man dressed as Bacchus, the Roman god of wine and intoxication, watches the 1963 parade alongside a young girl. W.C. Dannenbrink took this photograph for the *Canandaigua Daily Messenger*, where it appears with the following caption: "3rd annual grape fest in perfect weather. Considerably more in crowd than 20,000." (NPL/Messenger Post Media.)

From its beginning, the festival featured awards given to grape growers for outstanding vineyard culture, as well as to locals for cooking excellence. At right, the grape judging for the 1966 festival appears to have taken place in the town library. The Naples Grape Festival continues today, taking place each year in September. One of its most popular events is the World's Greatest Grape Pie Contest. (NPL.)

Six

VINEYARD VISIONARIES

Beginning in the 1950s, a few visionary winemakers began laying the groundwork for a Finger Lakes wine renaissance. Before and after Prohibition, it was common for New York wineries to blend up to 25 percent California juice into their wines or water them down. Water was used in making wine with native grapes for two main reasons: (1) the grapes' slip-skins and gel-like pulp make it difficult to extract enough juice during pressing, and (2) it toned down the grapes' foxy aromas and taste.

In 1944, Charles Fournier introduced French American hybrids to the region, planting 1,000 vines of Baco Noir and planning 1,000 more of Rosette—both red varieties. In 1950, Fournier's New York State Champagne Brut, made from these hybrids, won the only gold medal awarded at the California State Fair. At a 1953 wine conference, Fournier met Dr. Konstantin Frank, a Russian-born and -trained German viticulturist who had managed state vineyards in the Ukraine until World War II. Frank fled Ukraine with his family, eventually coming to the Finger Lakes to work at the NYSAES in Geneva. He started on April 15, 1952, doing propagation and fieldwork for the pomology department. Frank was convinced that European vinifera grapes could be grown successfully in New York, though his NYSAES colleagues disagreed. The station had been doing experimental work with vinifera on and off since 1902 but had yet to find evidence strong enough to recommend vinifera as commercially viable for New York State growers.

In 1954, Fournier hired Frank to begin propagating grafted vinifera varieties and planting them in experimental plots at Gold Seal. Meanwhile, Walter S. Taylor and his father, Greyton, believed French American hybrids were the future of Taylor Wine Company and the region. By 1965, Taylor wanted 3,000 tons of the white hybrid variety Aurore, with growers planting 50 acres of the variety annually to meet demand. Seven years earlier, Walter bought back his family's original vineyards on Bully Hill and replanted them to French American hybrids. Soon, Dr. Frank and Walter Taylor blazed separate trails, opening the only new independent wineries in the Finger Lakes during a 20-year period dominated by large corporations.

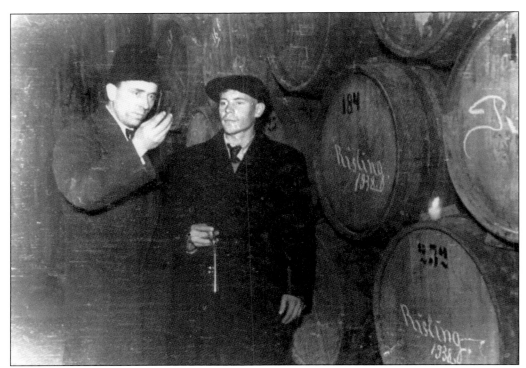

In the photograph above, Dr. Konstantin Frank (left) examines a barrel sample of vintage 1938 Riesling in a Ukrainian cellar. Below, Frank (sitting in the second row, fifth from left) rests with his Ukrainian vineyard crew during harvest around 1938. Frank believed improper rootstock, not the cold climate, caused the failure of European vinifera grapes in New York. He had successfully grown vinifera in the Ukraine, where temperatures regularly dropped below freezing. When he came to the NYSAES in 1952, Frank focused on propagation and fieldwork in the station's nursery. (Both, DKF.)

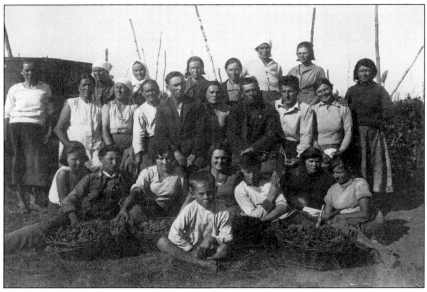

Dr. Frank only worked at the NYSAES for two years. At right is the original letter, dated March 2, 1954, from Charles Fournier to Frank, hiring him to be Gold Seal's vineyard consultant and to initiate the winery's experimental vinifera vineyards. In the spring of 1955, Frank began planting those vineyards with 40 vines each of Catawba, Ravat 6 (or Ravat Blanc), Pinot Noir, Pinot Gris, Cabernet Sauvignon, and Riesling grafted on a selection of native rootstocks. Below, an unidentified man lays drainage tile in the experimental vineyards at Gold Seal, with Keuka Lake spreading out below. (Both, DKF.)

GOLD SEAL
URBANA WINE COMPANY, INC.
NEW YORK STATE
GOLD SEAL CHAMPAGNE AND SPARKLING BURGUNDY
CHARLES FOURNIER CHAMPAGNE
SACRAMENTAL, TABLE AND DESSERT WINES

Hammondsport, New York
March 2
Our Eighty-Ninth Year
1 9 5 4

Dr. Konstantin D. Frank
28 Lyceum Street
Geneva, New York

Dear Dr. Frank:

This is to confirm to you that starting on March 1, 1954 you are retained by our Company as a consultant on vineyard matters at a fee of $1,800. a year, with special duties outlined in detail in your letter of February 27, 1954.

We will be very glad to help you in your endeavor in which we are interested and we hope that the success of your experiments will be complete, as it may mean quite a bit to our district.

I have given a copy of your letter and a copy of this letter to John Longwell, our vineyard manager, with whom we want you to work in complete cooperation and who, I am sure, will give you every possible help to get your nursery and experimental plots set up.

Yours very truly,
URBANA WINE COMPANY, INC.

Charles Fournier

Charles Fournier
President

CF:sg

cc: John Longwell

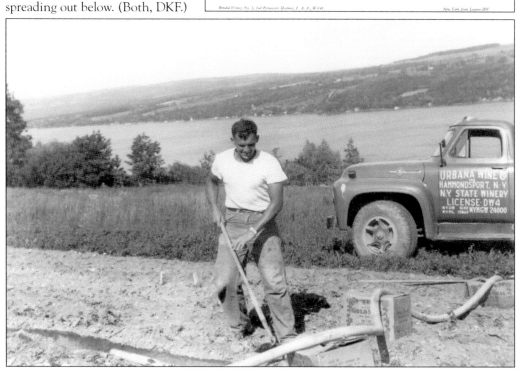

Like any good viticulturist, Dr. Konstantin Frank used a disciplined, scientific approach in his experimental vinifera vineyard at Gold Seal. Above, Frank poses with his young vines in the experimental vineyard on the terrace overlooking Gold Seal winery around 1955–1956. At right, a few years later, Frank happily holds up vigorous, healthy young vines in the same vineyards. Like he had done in the Ukraine and at the NYSAES, Frank used photographs to document his vineyard experiments. He appears in many of these, but often pressed friends and family to pose as well. (Both, DKF.)

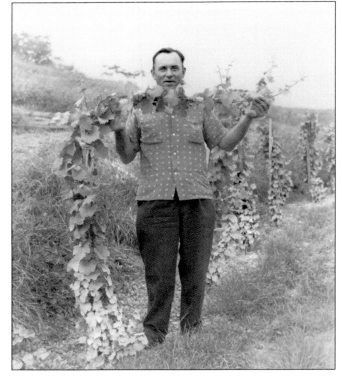

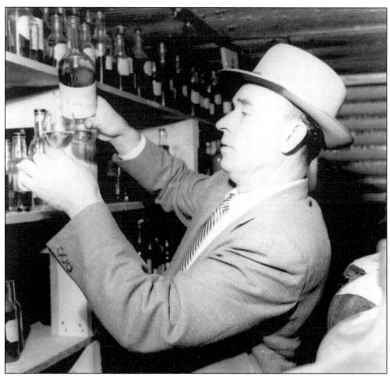

At Gold Seal, Dr. Frank's methodical vinifera experiments continued in the cellar. Above, Dr. Frank pours a wine sample in his laboratory at Gold Seal from what looks like a hand-labeled bottle of Riesling around 1958–1960. In 1959, after years of experimentation, Gold Seal produced the first commercial vinifera wines in the eastern United States, a Pinot Noir and Pinot Chardonnay. Dr. Frank also worked with Seneca Lake growers to plant more experimental vinifera vineyards for Gold Seal. At left, Waldo Beckhorn, whose vineyard and fruit farm in Valois on the east side of Seneca Lake had been in the family for over 100 years, poses for Frank with his son David in the experimental Chardonnay vineyard they planted for Gold Seal in 1962. (Both, DKF.)

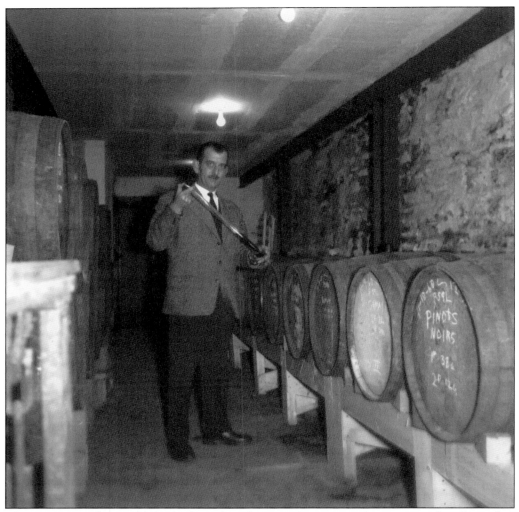

The same year that Gold Seal released its first vinifera wines, the company hired another Frenchman away from a famous Champagne house to assist Fournier with his fledgling vinifera production. In 1960, Guy Devaux arrived in Urbana from Moët & Chandon. Devaux was a chemist and winemaker by training and, like Fournier, had a special interest in sparkling wine. Devaux stayed with Gold Seal until Seagram & Sons bought the company in 1979. That year, Seagram's and its French champagne-producing partner G.H. Mumm tasked Devaux with finding an ideal American location for making sparkling wine. He settled on California's Napa Valley and founded Mumm Cuvée Napa in 1986. In this photograph, Devaux uses a tool called a wine thief to take barrel samples of the 1960 vintage Cabernet, Gamay, and Pinot Noir wines in Gold Seal's cellar. (DKF.)

In 1958, Dr. Frank planted his own vinifera vineyards just north of Gold Seal's. Above are, from left to right, Dorman Gleason, Eugenie Frank (Konstantin's wife), and Konstantin making the first cuttings from his new vineyards. In 1962, Dr. Frank opened his Vinifera Wine Cellars. He ran it like an agricultural experiment station, planting 60 different vinifera varieties to continue testing his vineyard theories. Below is the original road sign leading to Dr. Frank's Vinifera Wine Cellars around 1970. Dr. Frank's son Willy carried on his father's legacy, narrowing the winery's focus and founding Chateau Frank in 1980 to make acclaimed sparkling wines. Today, Willy's son Fred Frank is winery president, and his sister Barbara and daughter Meaghan have joined the family business. (Both, DKF.)

NEW YORK STATE TABLE WINE

Johannisberg Riesling

TROCKEN BEERENAUSLESE

PRODUCED & BOTTLED BY VINIFERA
WINE CELLARS DR. KONSTANTIN FRANK, HAMMONDSPORT, NEW YORK
ALCOHOL 12% BY VOLUME

Nr. 8646 KRUGMANN

Dr. Frank's motto was "only excellent will do" for American grapes, wines, and consumers. His dogged work in the nursery, lab, vineyards, and cellar produced the region's first acclaimed vinifera wines. One of these was his 1962 Trockenbeerenauslese. In German, this term translates to "dried berries selection" and indicates a medium to full-bodied dessert wine made from grapes that have been affected with "noble rot," which shrivels the grapes and concentrates their sugars for an intense honey-like flavor. Dr. Frank's version sold for $45 per bottle. Dr. Frank kept meticulous notes of his vineyard experiments; he took photographs to document the dates of his plantings, the varieties, and first harvest dates. Below, Frank peeks from behind a canopy of Gewürztraminer around 1965. (Both, DKF.)

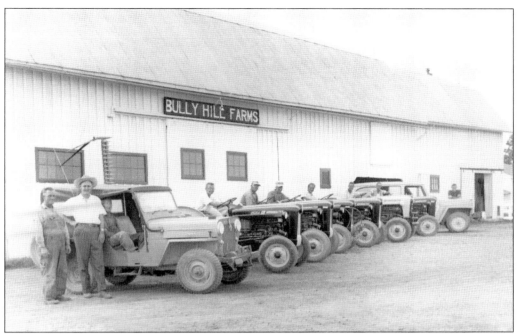

While Dr. Frank and Fournier focused on vinifera at Gold Seal, Walter Taylor took a different path. In 1958, Walter bought back his family's original winery to establish Bully Hill Farms. Above, Walter Taylor stands second from left, with tractors ready to work. Taylor ripped out native grape varieties, replacing them with French American hybrids. He believed these new hybrids, with their vinifera parentage and greater ability to withstand Upstate New York winters, were the answer for making quality wines from 100 percent New York grapes. Starting in 1964, Walter slowly built up his Lake Keuka Wine Company, seen below around 1966. (Both, BHV.)

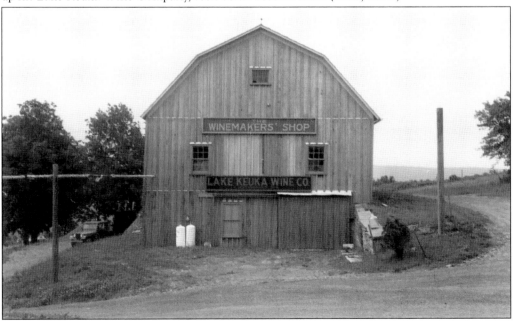

In 1967, Walter Taylor's Lake Keuka Wine Company released its first wine; at left is the company's inaugural vintage wine label. Below, employees of the Lake Keuka Wine Company celebrate their accomplishment. From left to right are Richard "Dick" Vine, Yolonda Wheeler, Walter S. Taylor, Paul Russell, Jeff Heath, unidentified, Bob Beauford, and Ellen Taylor, Walter's sister and co-owner of the winery. One year later, Taylor and Vine wrote and published a book together called *Home Winemaker's Handbook*. Taylor embraced New York's home winemakers and supported their quest to make better wines using only grapes grown in New York. (Both, BHV.)

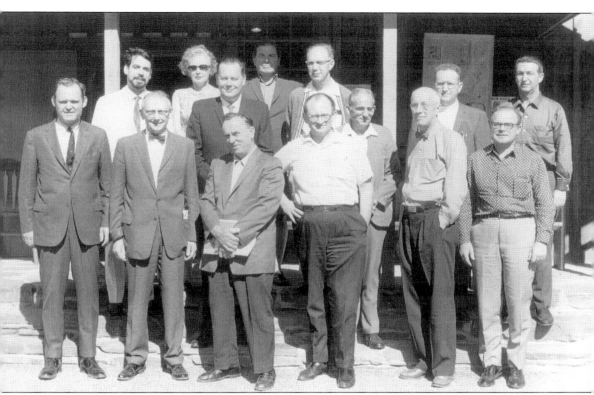

By 1967, news of Dr. Frank's success with vinifera and his focus on excellence spread to home winemakers and enthusiasts. That year, Frank invited his followers to a "convention" at his vineyard, the goal of which was to organize a group dedicated to promoting the growth of superior domestic American wines and their consumption. Thus, the American Wine Society (AWS) was born. Today, the AWS has over 4,000 members in 120 chapters across 45 states. Here, board members pose at their first meeting in June 1968. They are, from left to right, (first row) Walter S. Taylor, Aldus "Al" Fogelsanger, Dr. Konstantin Frank, Don Herman, Albert Laubengayer, and Kenneth A. Proctor; (second row) ? Axtel, Mrs. Danenhauer, ? Borgstedt, ? Danenhauer, Harold Applegate, G. Hamilton Mowbray (a pioneer in Maryland winemaking who established Montbray Wine Cellars in 1964), Harry A. Kerr, and Tom Clarke. (DKF.)

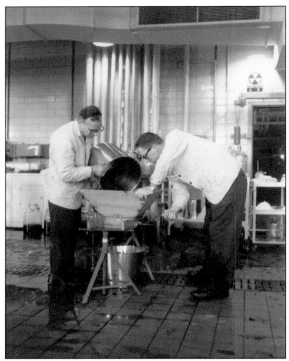

During the 1960s, new varieties and better winemaking practices began turning consumers' tastes toward dryer, unfortified wines. In the Finger Lakes, Dr. Frank and Walter Taylor were not the only forces moving toward higher quality. At the NYSAES in Geneva, researchers saw the juice market becoming saturated and problems mounting for wine grape growers. In 1964, the region's winemakers finally agreed to fund an expanded grape and wine research program; the NYSAES soon became a hub for eastern grape-breeding and winemaking research. At left, NYSAES researchers use a hand-cranked grape crusher in the lab on October 17, 1968. Below, Widmer's Wine Cellars honors Dr. John Einset (right) and Dr. Willard B. Robinson from the NYSAES in 1972 for developing the new hybrid wine grape variety Cayuga White. (Both, FALL.)

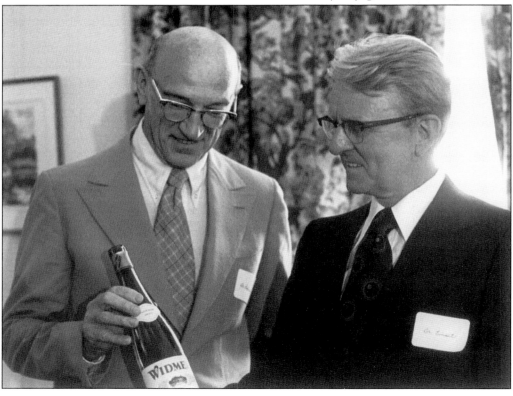

Seven

THE FARM WINERY REVOLUTION

By the mid-1970s, a relative latecomer had taken control of the few remaining independent wineries in the Finger Lakes. Marvin Sands founded Canandaigua Wine Company in 1945 to sell bulk wine to eastern bottlers. Sand's first success was in 1954 with Richard's Wild Irish Rose, a sweet, fortified Concord wine. Starting in 1977, Taylor/Great Western, Gold Seal, and, eventually, Widmer's Wine Cellars were bought by a series of international beverage companies before Canandaigua Wine Company purchased all three in 1993. Today, the company is called Constellation Brands and is the largest wine producer in the world, with more than 100 wine, beer, and spirit brands in its portfolio.

These consolidations nearly ruined Finger Lakes grape growers. For years, local wineries had been buying fewer New York grapes in favor of out-of-state juice. Growers were left without a market. They thought about making their own wine, but licensing regulations and fees were too onerous for small producers. Soon, a dedicated group of politicians, winemakers, and agricultural economists took up the cause. In 1976, Gov. Hugh L. Carey signed the New York State Farm Winery Act, lowering licensing fees and allowing growers to make and sell wine from their farms. The work and vision of Charles Fournier, Dr. Konstantin Frank, and Walter Taylor marked the beginning of the region's wine renaissance, but the 1976 Farm Winery Act fueled a grassroots revolution.

This chapter goes behind the scenes of the early farm winery movement, focusing on a handful of the first farm wineries, as well as the restaurateurs, publishers, and politicians who provided crucial support. This is not a complete survey of every early farm winery in the Finger Lakes; it is instead meant to convey the spirit of that time—experimental, communal, and cooperative. The first farm wineries were largely family affairs, multigenerational growers like the Taylors, Hazlitts, and Wagners. Others were wine lovers eager to get "back to the farm." Friends helped in the vineyard, basements served as cellars, and equipment was do-it-yourself. In 1970, only two independent wineries remained in the Finger Lakes; today, there are 119.

Politicians and wineries worked together to pass the 1976 Farm Winery Act. Here, Lt. Gov. Mary Anne Krupsak (center) tours the Pleasant Valley Wine Company with Frederic Schroeder (left), managing director, and Jim Doolittle (right) around 1976. Krupsak was instrumental in pushing the farm winery agenda. Doolittle, an agricultural economist, helped craft the legislation and later opened a winery on Cayuga Lake. (FPV.)

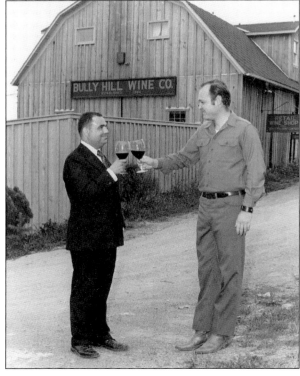

Walter Taylor (right) also used his influence to help the movement. Here, he toasts Ernest Gallo Jr. at his renamed Bully Hill Wine Company around 1973. In 1933, Ernest cofounded E&J Gallo Winery in Modesto, California, with his brother Julio. Walter must have felt a kinship with Gallo since both had grape-growing roots and had built wineries from the ground up. (BHV.)

The farm winery push included a rare February 1976 tasting of New York State wines at the Four Seasons Hotel in New York City. The event, organized by Carol Doolittle while working for the New York State Department of Agriculture & Markets, was the first of its kind. Here are some original labels from the event's wine catalog. The Taylor champagne was made under the ownership of the Coca-Cola Company, with Michael Doyle (current owner of Pleasant Valley Wine Company) serving as president of Taylor/Great Western. The Gold Seal Pinot Chardonnay label uses an outdated varietal name for Chardonnay. The 1974 Boordy Vineyards Landot Noir was a red hybrid wine made in Penn Yan by the affiliated winery of Philip Wagner's Boordy Vineyards in Maryland. The affiliation ended two years later. (Both, FPV.)

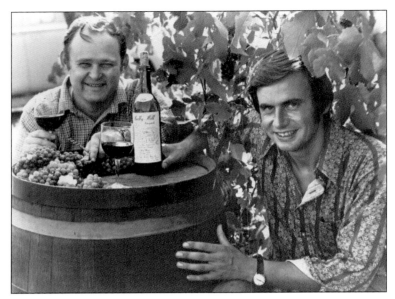

Walter S. Taylor (left) and his winemaker at the time, Hermann Wiemer, pose with a vintage 1970 Bully Hill red wine. Taylor hired Wiemer, a German, to make wine and propagate French American hybrids on a large scale in his nursery. In the early 1960s, Wiemer briefly worked at O-Neh-Da Vineyards. (BHV.)

In Germany's Mosel Valley, Wiemer's family had been growing grapes and making wine for generations. He attended the Viticultural Institute in Neustadt and, while there, worked with Dr. Helmut Becker, chief of the renowned Geisenheim Grape Breeding Institute, to help combat the grape pest phylloxera by breeding new disease- and cold-resistant German American hybrids. From left to right are Wiemer, Dr. Frank, Walter Taylor (standing), and Dr. Becker. (DKF.)

Behind the scenes, influential entrepreneurs and writers were helping the Doolittles promote the farm winery cause. Bill Moffett, a local grape grower and entrepreneur, created *Eastern Grapegrower* magazine and the first trade show for eastern grape growers and winemakers. In 1976, the first Wineries Unlimited conference was held in Lancaster, Pennsylvania. At right, Carol Doolittle presents a bottle of wine to Leon Adams, known as "the dean of American wine writing," at the inaugural conference. Moffett's shoestring publication evolved into *Vineyard & Winery Management* magazine, a leading trade publication for the North American wine industry. Below, Gold Seal winemaker Charles Fournier (seated at center) and his wife (seated second from left) toast Jim and Carol Doolittle (standing at right) and other 1976 conference attendees. (Both, FPV.)

On June 10, 1976, Gov. Hugh L. Carey signed the New York State Farm Winery Act into law. It could not have happened without support from the remaining big Finger Lakes wineries, outspoken pioneers (Walter Taylor at Bully Hill, Mark Miller at Hudson Valley's Benmarl Winery, Dr. Frank), enthusiastic politicians, and promoters like Moffett and the Doolittles. Here, Walter S. Taylor (holding pipe) presents grapevine cuttings to Governor Carey (third from left) to commemorate the signing of the Farm Winery Act. Jim Doolittle stands behind Taylor, to the right. The Farm Winery Act cleared the way for Finger Lakes grape growers to profit directly from their vineyards and the establishment of a quality wine industry founded on New York–grown grapes. It also gave amateur and professional winemakers a viable path for realizing dreams of growing, producing, and selling their own wines. Some of these aspiring winemakers came from outside the region; others were from a new generation of Finger Lakes grape growers whose families had years of vineyard experience. (FPV.)

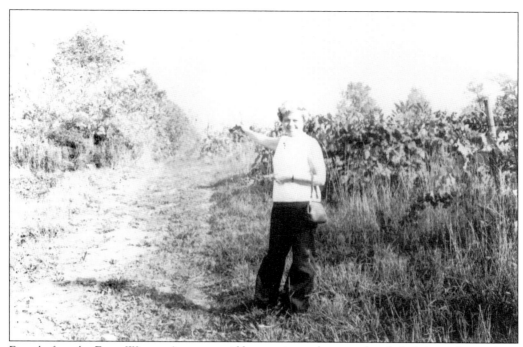

Even before the Farm Winery Act, one avid home winemaker was already helping to bring about the return of small wineries on Keuka Lake. In the 1960s, Bob McGregor was working at Kodak and living in Rochester with his family, but his vision was growing grapes. Here, Elizabeth Stewart poses in the abandoned vineyard she and husband David partnered with McGregor to purchase in 1969. (MVW.)

In 1972, Bob began planting the first of what would become 28 acres of vinifera and French American hybrid grapes overlooking the east bluff of Keuka Lake. At the time, Bob was known as an "oddball" for planting vinifera. Here, Bob McGregor (right) and Pete Wintergreen plant the new vineyard in June 1973. Dave Hall drives the tractor. (MVW.)

As a red wine lover, Bob was determined to find a New York grape from which to make a quality red wine. He was buoyed by both Dr. Frank's success with vinifera and Walter Taylor's hybrid wines. However, McGregor's initial goal for establishing his vineyard was to have a source for quality wine grapes for home winemaking. His homemade wines were shared with friends and fellow AWS members, a community of like-minded amateur winemakers. The McGregor vineyard hosted many family-friendly AWS picnics in the early 1970s. The picnics also were an opportunity for members to share winemaking and grape-growing knowledge. Above, Bob gives a vineyard tour around 1975 while an unidentified boy playfully aims his toy pistol. Below, Bob's young son John works the beverage bucket. (Both, MVW.)

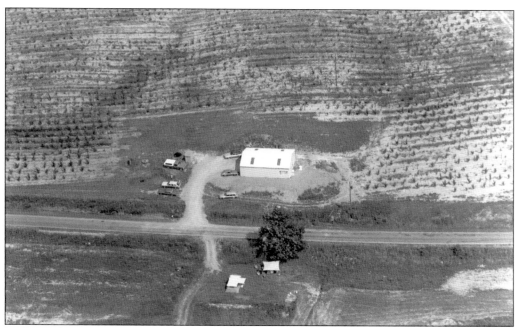

In the early 1970s, the McGregors had a single building and 28 acres of young vines. There was no house on-site; during the summers, the family would drive down each weekend from Rochester to camp on their property. Above is an aerial photograph of, from top to bottom, the young vineyard, the single building, and the McGregors' campsite. In 1976, Bob bottled his first wines from this site, estate-grown Chardonnay, Riesling, and Cabernet Sauvignon. In 1980, he opened a farm winery but did not devote himself to full-time winemaking until 1986. Below, in 1980, Bob McGregor uses a hydraulic basket press to make his winery's first vintage. (Both, MVW.)

Winemaking was and still is a family affair at McGregor Vineyards. As a boy, John McGregor, who now owns and manages the winery, helped his father with every step in the winemaking process, from harvesting to crushing to bottling. Above, John helps his father during pressing around 1985. For many years, the McGregors labeled wine bottles by hand. Hand labeling is still common today in smaller wineries. Below, Bob's wife, Marge, glues on labels and then uses a handheld heat shrinker—the tool resting on the table that resembles a hair dryer—to seal each bottle with a tight PVC capsule. (Both, MVW.)

The McGregors had a special bond with Walter S. Taylor (center) and wife Lillian (left), captured with Bob in this photograph taken in 1985, five years before the car accident that confined Taylor to a wheelchair. Taylor was a generous collaborator in Bob's vineyard experiments and a champion for quality New York State wines. (MVW.)

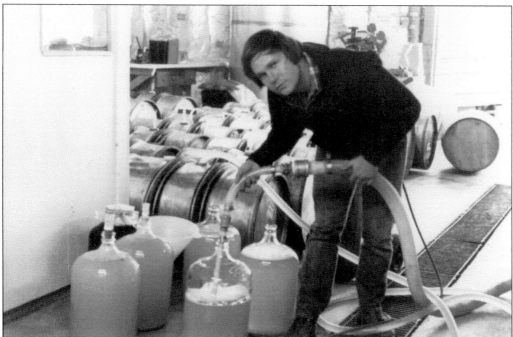

Here, original co-winemaker John Moss fills glass carboys at McGregor Vineyard in the 1980s. Today, John McGregor and his wife, Stacey, run McGregor Vineyard, producing between 6,000 and 8,000 cases per year. All of their vinifera grapes are estate grown, including three lesser known vinifera varieties from Eastern Europe: Sereksiya Charni, Saperavi Rkatsiteli, and Sereksiya Rose. (MVW.)

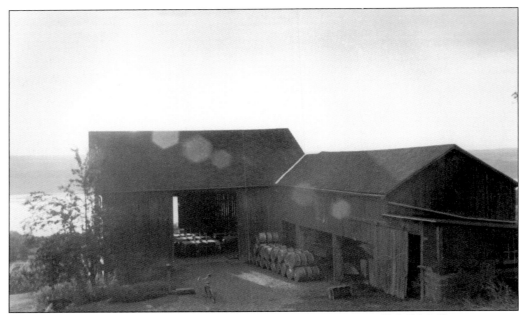

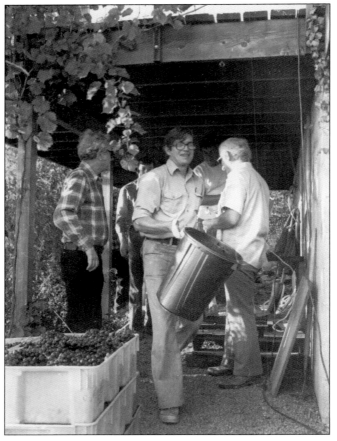

In 1965, Bill Moffett, a young academic publishing editor, transferred to the Finger Lakes from Oregon. In 1970, he bought an 84-acre vineyard in Hector on the southeastern shore of Seneca Lake and began replanting old native vineyards with French American hybrids and vinifera. Five years later, Moffett founded *Eastern Grapegrower* magazine. Harvest at Moffett's farm was a community affair: friends picked and crushed grapes, then enjoyed a well-deserved dinner in the barn. Above, the sun is setting on Seneca Lake and Moffett's barn, set up for the post-harvest dinner around 1975. At left, Moffett (wearing glasses) and friends crush grapes under his back porch. (Both, FPV.)

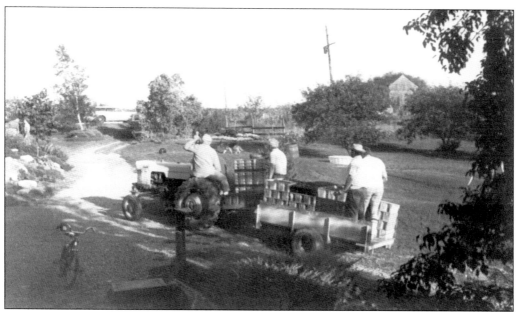

Above, friends bring a tractor load of grapes up from the vineyards to Bill Moffett's house for crushing. The view is looking up from the lake toward State Route 414. In 1980, Moffett sold his vineyard to Ed and Joanne Grow, who opened Rolling Vineyards Farm Winery. The Grows planted more varieties, including Riesling, Gewürztraminer, and Vidal Blanc, and used the old barns for production and tastings. Rolling Vineyards won the first New York State Governor's Cup, but the Grows closed the winery in 1989 to focus on grape growing. Entrepreneur Ted Marks purchased it in 1999 and opened Atwater Estate Vineyards in September 2000. Below is a c. 1981 Rolling Vineyards label featuring another original drawing by Ithaca artist Bill Benson. Today, these barns have been completely renovated as Atwater's tasting room/facility. (Both, FPV.)

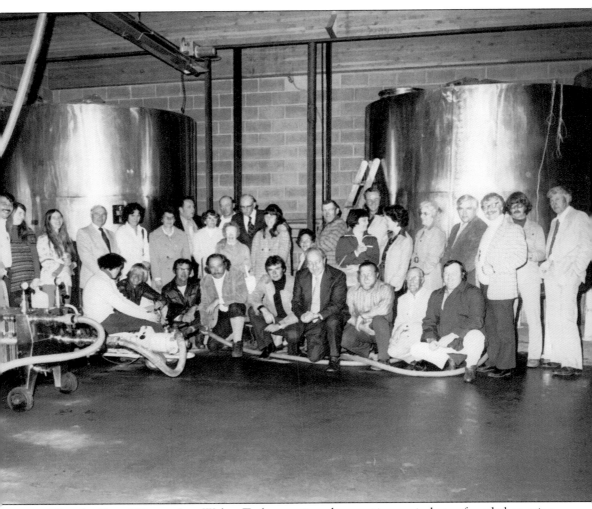

After the Farm Winery Act, Walter Taylor continued promoting an industry founded on wine made only from New York grapes. At Bully Hill in April 1977, Taylor hosted Finger Lakes growers who had sold grapes to him in the fall of 1976 to announce what he told the *Geneva Times* was "history in the making": the launching of his Walter S. Taylor line of wines, whose labels would bear the names of the growers whose grapes were used to make each wine. Winemaker Hermann Wiemer developed these limited edition wines using French American hybrid grapes from selected growers. As reported in the *Geneva Times*, the label on a bottle of Walter S. Taylor rosé wine listed the following growers: Bill Wagner, Lee Gibson, Ken Barber, Lewis Green, Bob Johnson, Lyman Thomas, Wallace Griffin, Roger Allen, Nell Simmons, Elmer Frederiksen, and J. Hazlett [sic]. This group poses for a photograph in Bully Hill's tank room. Taylor (with mustache) kneels in the center, with Wiemer seen kneeling to the right of him. Bill Wagner stands at far right. (WV.)

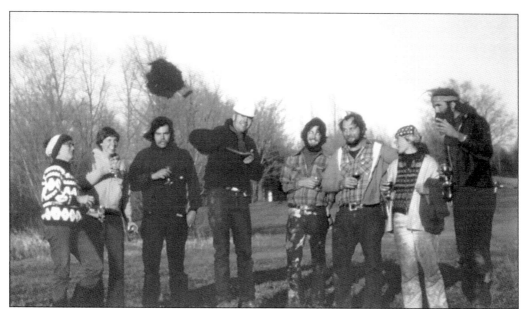

The Farm Winery Act brought back the first wineries on Seneca Lake since the 1890s. The first of these was Glenora Wine Cellars, founded in 1978 on the western shore of Seneca Lake in Dundee. Next was Wagner Vineyards. In 1976, Stanley Wagner (known to all as "Bill") was selling grapes to Bully Hill while planning his own winery. He was a third-generation grape grower on the eastern shore of Seneca Lake; his father and grandfather had sold grapes to the table and juice markets. Above, Bill Wagner, surrounded by friends and coworkers, breaks ground at Wagner Vineyards in 1976. Third from left is John Herbet, Wagner's second winemaker. Below, a worker loads Wagner grapes bound for Welch's in the 1950s. (Both, WV.)

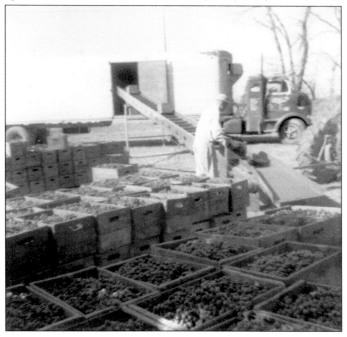

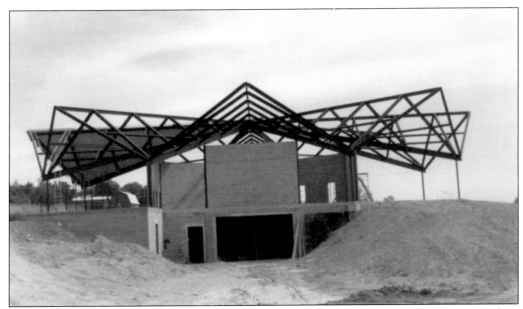

Bill Wagner's vision included a unique eight-sided winery building of his own design, a modern take on the round barns popular in the 18th and early 19th centuries. The Wagners did most of the construction themselves. After the cellar and foundation, the roof trusses (made of huge iron beams) were craned into place. This is a photograph of the building in progress. (WV.)

Here, three generations of Wagners survey progress on the new winery's cellar and foundation around 1978. Pictured with Bill (right) are his son John and his father, Stanley. In the 1920s, Stanley Wagner and his wife, Alta Button Wagner, moved to a farm in Caywood, just down the road from Wagner Vineyards. (WV.)

John Wagner, seen here around 1967, has been working in the vineyard since he was old enough to hold pruning shears. Today, John manages operations at Wagner Vineyards alongside his brother Stephen and sister Laura Wagner-Lee. Several of Bill's grandchildren also are involved in the winery, from the restaurant to the cellar. (WV.)

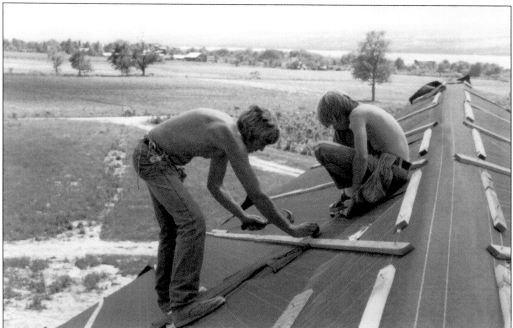

Here, Bill Wagner and son John do the hot work of roofing the new winery around 1978. The view is looking southwest from the rooftop toward Seneca Lake. The western shore of the lake is visible, and the Wagner vineyards can barely be seen in the middle right. The winery took three years to complete. (WV.)

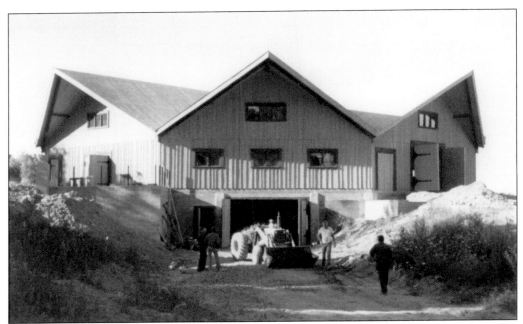

Above, the finished Wagner winery building sits atop the stone cellar around 1979. The cellar housed 1,500-gallon oak casks for storing and aging wine. In 1978, Wagner crushed its first grapes for the new winery. The first vintage was a 1978 Seyval Blanc (below), a French American hybrid varietal made by winemaker Dave Bagley. Not long thereafter, Bagley founded his own winery, Bagley's Poplar Ridge Vineyards, on Seneca Lake, just south of Wagner's. Wagner initially became known for the quality of its estate-grown white wines, such as Seyval, Chardonnay, and Riesling. (Both, WV.)

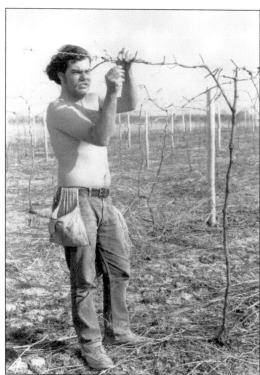

Vineyard work is manual labor, even if it is another gorgeous day in the Finger Lakes. Winemaker John Herbert (right) does spring tying with Ann Raffetto (below) around 1983. Herbert met Bill Wagner in 1975 while working for the construction company that Bill had hired to build a workshop. After discovering their shared interest in winemaking, Bill hired Herbert to work in the vineyards and help build his winery. In 1982, Wagner's first winemaker returned to California, and Herbert took his place. A California native, Raffetto joined the winemaking team in 1983; she and Herbert made wine together for 30 years, until his retirement. Raffetto is now Wagner's head winemaker. (Both, WV.)

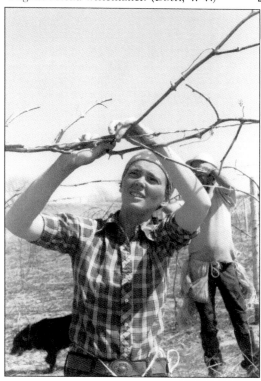

Today, Wagner Vineyards cultivates 20 grape varieties on 250 acres of land. The business also now includes a café (opened in 1983) and brewery (opened in 1997). Bill Wagner passed away in 2010, leaving the business to be carried on by his children, grandchildren, and dedicated winemaking team. Here, Bill poses in front of his eponymous winery holding estate-grown grapes around 1979. (WV.)

By 1984, the Hazlitt family had been successful fruit farmers on the east side of Seneca Lake for more than 130 years. In 1852, David and Clarissa Hazlitt bought 153 acres in Hector; since then, the family had been shipping grapes and other produce, including peaches, across the region by wagon, boat and eventually train via the busy Hector LV depot. (HV.)

GREETINGS FROM HECTOR, N. Y.

L. V. R. R. STATION

At right, Jim Hazlitt, fourth-generation grower, picks peaches on his Hector farm in the 1950s. Jim and his wife, Elizabeth, lived in the Hazlitt family homestead on Route 414, bought by Jim's grandfather about 1900. The Prohibition years were lean, but by 1944, eastern grape prices, including in New York, had risen from $36 per ton in 1936–1939 to $81 per ton. Big Finger Lakes wineries like Great Western and Widmer's had contracts with Hazlitt to buy his grapes each year. Below, a Hazlitt vineyard crew takes a break around 1944. From left to right are Ralph Kendall, Mort Goltry, Red Sweet, Irene Jenkins Hubbell, Bill Kelly, and Lillian "Mrs. Eddy" Edminister. (Both, HV.)

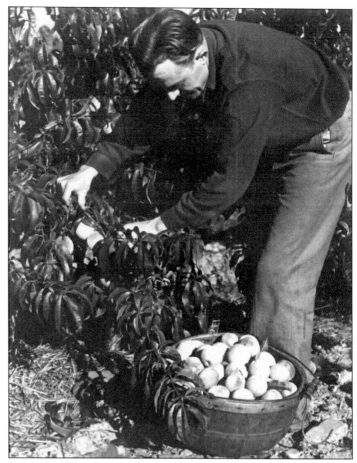

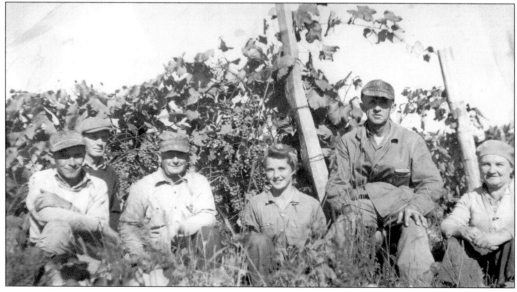

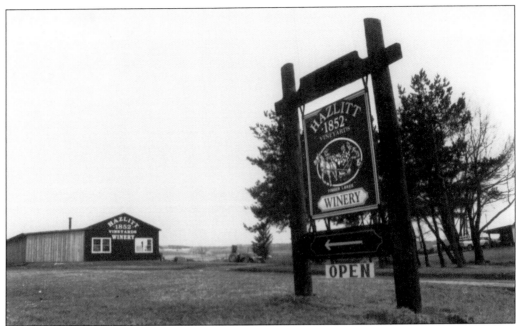

In 1984, Taylor Wine Company and Gold Seal Winery canceled all contracts with Finger Lakes growers. The Hazlitts were forced to find a new business or sell the farm. Jerry Hazlitt, one of Jim's two sons who now owned half of the family's land, chose to use his vineyards to open a winery with his wife, Elaine. Hazlitt 1852 Vineyards opened in 1985. Above is the original winery building, as seen from Route 414 in Hector. Below, Jerry Hazlitt checks the crusher/destemmer during harvest in the 1990s. In 2010, Hazlitt Vineyards purchased the Widmer's Wine Cellars facility in Naples; it is now home to Hazlitt's Red Cat Cellars and East Coast Crush & Co-Pack, a custom crushing, winemaking, and packing business. Jerry's brother Jim owns Sawmill Creek Vineyards, grower of premium grapes for many Finger Lakes wineries. (Both, HV.)

One of the first wines Hazlitt made was a sweetened blend of Catawba and Baco Noir grapes. Red Cat is still one of the winery's most popular blends, but Hazlitt also makes more than 13 vinifera and specialty wines. Founder Jerry Hazlitt passed away in 2002, then wife Elaine in 2007; they are seen here together around 2000. Today, their son Doug and daughter Leigh Hazlitt Triner continue the family-run winery. (HV.)

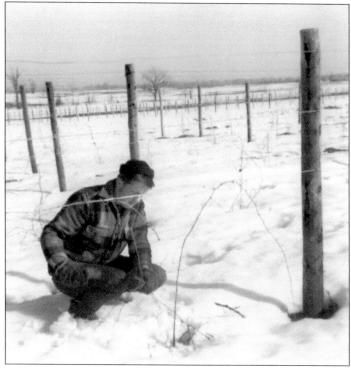

Though vineyards had existed on the east side of Cayuga Lake since the late 1880s, no wineries opened there. In 1969, Richard "Dick" Peterson and his wife, Cindy, planted a vineyard in Romulus with French American hybrids to sell grapes part-time to the remaining Hammondsport wineries. Here, Dick Peterson inspects mouse-eaten vines in his young vineyard in March 1971. (SHW.)

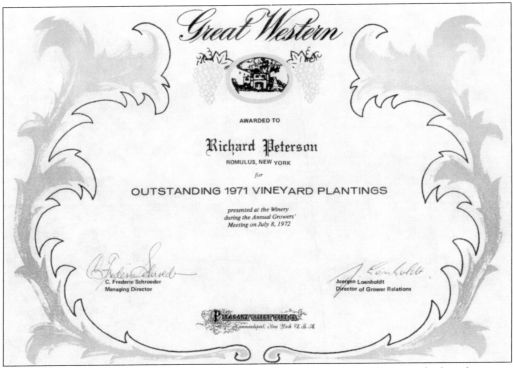

Great Western

AWARDED TO

Richard Peterson

ROMULUS, NEW YORK

for

OUTSTANDING 1971 VINEYARD PLANTINGS

*presented at the Winery
during the Annual Growers'
Meeting on July 8, 1972*

C. Frederic Schroeder
Managing Director

Juergen Loenholdt
Director of Grower Relations

PLEASANT VALLEY WINE CO.
Hammondsport, New York U.S.A.

In 1972, the Pleasant Valley Wine/Great Western Company awarded Peterson for his plantings. This was the same year that Walter Taylor's outspoken views on his family's winemaking practices finally led his uncles to fire him from the Taylor Wine Company. By 1981, the Petersons—still working jobs in other industries—had established a prosperous grape-growing business with vineyards producing mainly hybrid grapes for wineries like Taylor and Pleasant Valley. Three years later, the bottom finally dropped out of the Finger Lakes wine grape market. Below is an aerial view of the Petersons' farm and vineyards in 1981. (Both, SHW.)

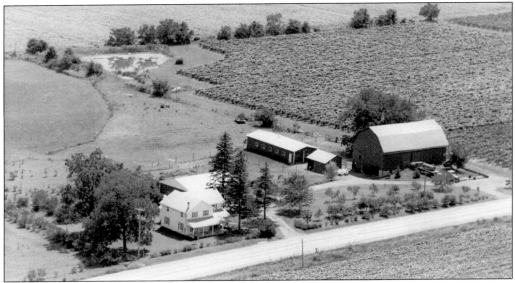

In 1982, the Petersons ventured into vinifera. Here, Dick Peterson drives the tractor while son Dave plugs grafted Chardonnay vines into the furrows. In 1985, after being stuck with about 25 tons of unsold Catawba grapes, Peterson crushed the first grapes for his new Swedish Hill Winery, producing 1,200 cases. (SHW.)

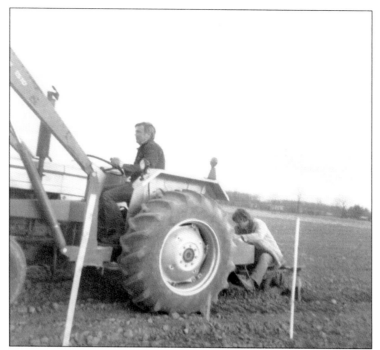

Today, Swedish Hill produces over 60,000 cases annually and is operated by Dick's son Dave and his wife, Jean, who also own Goose Watch and Penguin Bay wineries. In 1994, Swedish Hill won the Governor's Cup award. Also pictured in that year, owners Dick and Cindy Peterson discuss grape and wine quality with Robert M. Pool (left), professor of viticulture at Cornell. (Photograph by Kevin Colton/NYSAES; FALL.)

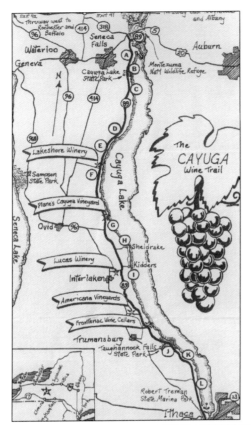

In 1981, Bob and Mary Plane opened Plane's Cayuga Vineyards (today, Cayuga Ridge Estates) on the west side of Cayuga Lake. Like the Petersons, they had been growing grapes since the early 1970s for Taylor/Great Western. When the winery struggled to attract visitors, Mary hatched the idea of partnering with other wineries to promote tourism; in 1983, the Cayuga Wine Trail was born. It is the first and longest-running wine trail in America, currently boasting 15 wineries. This map in the original brochure shows the wine trail and its founding members, including Frontenac Point Vineyard & Estate Winery, owned by Jim and Carol Doolittle. Jim planted his first vines in 1979 and opened in 1982 with 400 cases of wine made in his basement. Below, Jim takes a barrel sample around 1984. (Both, FPV.)

The farm winery movement paved the way for a blossoming farm-to-table restaurant movement in the Finger Lakes. In the early 1980s, Michael Turback, a 22-year-old Cornell graduate, opened Turback's of Ithaca, specializing in "regional N.Y. State Cooking and premium N.Y. State Wines." Turback's used ingredients sourced almost exclusively from New York and featured the first-ever all–New York wine list, with selections from the Finger Lakes, Erie-Chatauqua, Hudson Valley, and Long Island regions. At right is the cover of Turback's c. 1983 souvenir edition wine list. Turback also wanted to sell his own locally made wine to customers, so he asked the Doolittles to produce it. Turback and his dining room staff helped tend the vines and harvest grapes for his house wines. Below, Turback's staff rests during the 1984 harvest at Frontenac Point Vineyards. (Both, FPV.)

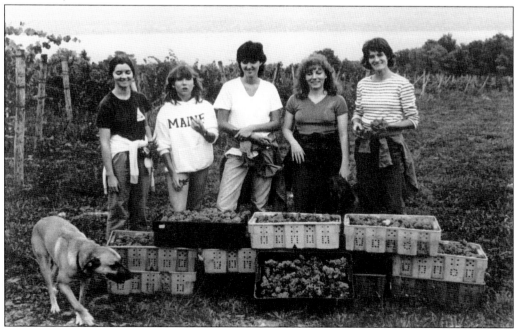

Michael Turback loads grapes into the crusher under the Doolittles' back deck. Frontenac's vineyards and Cayuga Lake can been seen to Turback's right. Turback sold his restaurant in 1997 but continues to write tourism guides, cookbooks, and other publications promoting New York food, wine, and spirits. (FPV.)

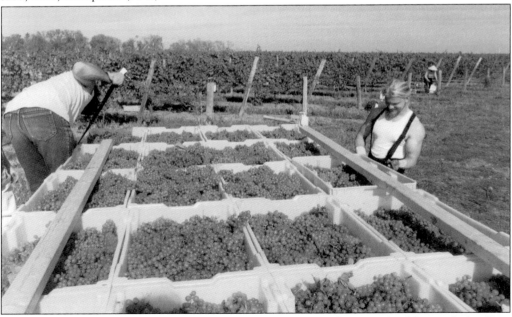

In 1988, Peter and Tacie Saltonstall founded the first winery on the east side of Cayuga Lake. King Ferry Winery is located just north of Ithaca on family land known as the Treleaven farm. The winery first gained recognition for its estate-grown Chardonnay. Today, Chardonnay continues to be one of King Ferry's signature wines. This photograph shows another bountiful grape harvest at King Ferry. (KFW.)

In 1968, Hermann Wiemer established the greenhouse above to grow French American hybrid rootstock for Bully Hill. His skill at grafting vines—connecting the rooting portion of one variety to the scion, or fruiting portion, of another—was well known. Eight years later, Wiemer used those skills to plant his first vinifera vineyard on the western shore of Seneca Lake. In 1980, he opened his own winery, Hermann J. Wiemer Vineyard; that Christmas, Bully Hill and Wiemer parted ways. Like Dr. Frank, Wiemer believed vinifera was the future of Finger Lakes wine; he epitomizes that sentiment in the c. 1997 photograph below. Today, Wiemer's legacy is carried on by winemaker Fred Merwarth, as well as by the next generation of wineries and entrepreneurs crafting diverse, quality wines expressive of today's Finger Lakes wine country. (Above, BHV; below, HJWV.)

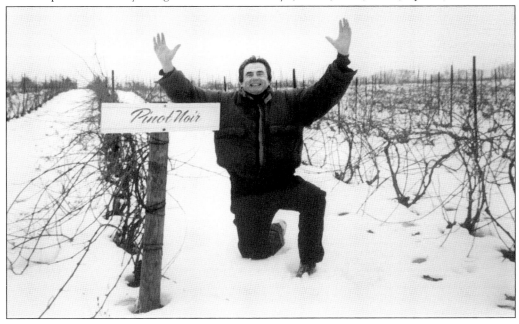

Discover Thousands of Local History Books
Featuring Millions of Vintage Images

Arcadia Publishing, the leading local history publisher in the United States, is committed to making history accessible and meaningful through publishing books that celebrate and preserve the heritage of America's people and places.

Find more books like this at
www.arcadiapublishing.com

Search for your hometown history, your old stomping grounds, and even your favorite sports team.